HENLEY-ON-THAMES THEN & NOW

IN COLOUR

JOHN PILLING & LAURENCE WATERS

First published in 2011

The History Press
The Mill, Brimscombe Port
Stroud, Gloucestershire, GL5 2QG
www.thehistorypress.co.uk

British Library Cataloguing in Publication Data.
A catalogue record for this book is available from the British Library.

ISBN 978 0 7524 6364 3

Typesetting and origination by The History Press
Production managed by Jellyfish Print Solutions and manufactured in India

CONTENTS

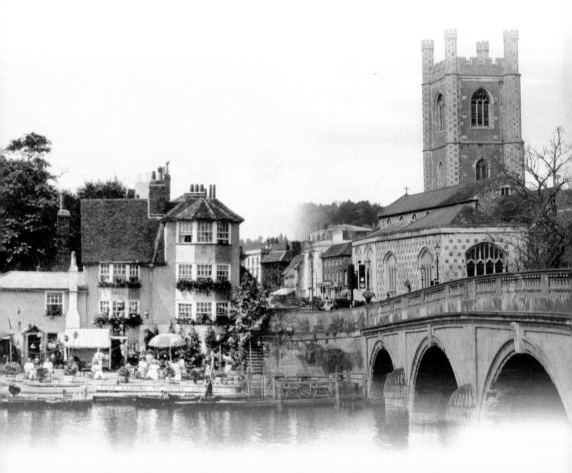

ACKNOWLEDGEMENTS

Unless otherwise stated, the old photographs in this book are from Oxfordshire County Council's *Images and Voices*. They were previously published in *Henley on Thames Past and Present* by John Pilling and Lorraine Woods.

Photograph credits are as follows:

Brakspear Pub Company 20, 87
Bushells Photographic 9, 10, 14, 16, 26, 28, 36, 45, 51, 57, 59, 62, 64, 84
Great Western Collection 74
Henley Standard 12
River and Rowing Museum, Henley-on-Thames 18, 38, 69
South Oxfordshire District Council 70

The new photographs were taken by Laurence Waters in 2011. The authors would like to thank the staff at the Henley Pharmacy, the Patisserie Franco-Belge, Trinity Church of England School, the Red Lion Hotel and Mr Keith Thatcher, postman.

Readers interested in further exploring the history of the town and river are advised to visit Henley Library in Ravenscroft Road and the River and Rowing Museum on Mill Meadows, which has specialist collections on the social and natural history of the river Thames and on the international sport of rowing as well as on the history of Henley.

ABOUT THE AUTHORS

John Pilling built up his knowledge of the fascinatingly diverse history of the towns and villages of Oxfordshire whilst working in the Centre for Oxfordshire Studies in Oxford Central Library, and here he published his guide to the local vernacular architecture of the county: *Oxfordshire Houses: A Guide to Local Traditions*. However, his interest in local history dates back to his undergraduate days at Corpus Christi College, Cambridge, where he gained a BA in history, and he developed this interest with an MA from Loughborough University in 1983. He has since worked as a professional librarian specialising in local history and is now a Principal Librarian with the Oxfordshire Library Service.

A retired professional photographer and photography teacher, Laurence Waters has written or contributed as co-author to twenty-seven books on local history subjects. His main interest is the Great Western Railway, and he has written a great many books on the subject. Laurence is the honorary photographic archivist for the Great Western Trust at Didcot Railway Centre.

INTRODUCTION

Henley-on-Thames is no ordinary riverside town. Its name conjures up an image in people's minds across the world of the fashionable elite at leisure, of affluent living and of rowing at its best. Henley has made a name for itself. However, the pictures in this book show that this was not always so, and many of the early photographs in this book show shabby and poorly kept houses, empty warehouses and muddy and ill-paved streets.

Henley grew up as a river port and its origins can be traced back to the early twelfth century. Barges used to moor along wharves on the river banks to load up with corn, malt, building stone and timber for onward shipment to London and beyond, whilst incoming barges brought luxuries from the metropolis to be unloaded onto pack horses. During the eighteenth century Henley became a convenient stopping place for coaches travelling between London and the west using the new turnpike roads. Old inns such as the Bull and the White Hart took on a new lease of life, and others were rebuilt in a grander style such as the Red Lion and the Angel.

The opening of the Great Western Railway to Reading brought about a sudden collapse in Henley's river and road trade. Although a branch link with the main line at Twyford was established in 1857, Henley had lost out in the railway age. The town had to find itself a new living. Residents remembered how many visitors had come to the town in 1829 when the University Boat Race was held on their stretch of the Thames and they decided to stage their own one-day event in 1839. By the end of the century it had become firmly established in the English calendar of social events. The regatta, combined with a splendid setting in the Thames Valley, soon attracted visitors and permanent residents alike to the town. Travel time by train to Paddington had been reduced to a little over an hour by 1900 and it was now possible to commute daily to a city office or to make a day trip from London or Reading. A new prosperity and pride had begun to revive the town's spirits: luxury hotels were built to accommodate fashionable visitors, firms hiring out pleasure boats acquired new premises and grand mansions were constructed.

Large employers have never dominated the town, but brewing has long been one of Henley's main industries, and the sole survivor, W. H. Brakspear and Sons, continued to brew here until 2002.

Henley avoided wholesale redevelopment in the twentieth century, knowing that its prosperity has been built on its reputation as a desirable place to visit and live. The photographs show a remarkable continuity in the fabric of the town, but many of the family-owned shops have been replaced by chain stores, modern development has changed the look of some streets forever, and, with access from the east confined to the single eighteenth-century bridge, modern traffic has brought new challenges.

THE TOWN CENTRE

HART STREET LOOKING towards St Mary's church on a market day in about 1887 (opposite). Most of the carts in this picture seem to have been parked for the day and one assumes that the horses have been put out to graze on a nearby meadow.

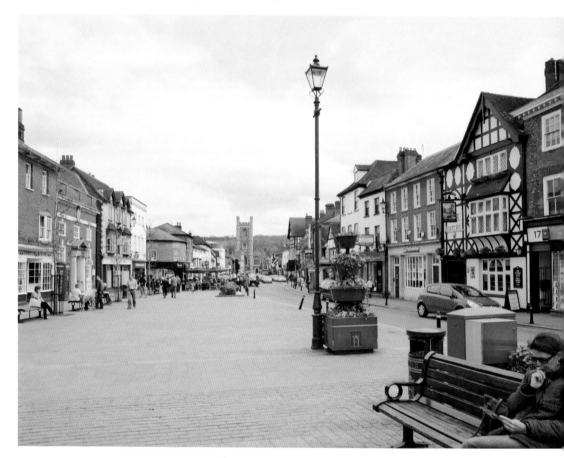

THE TOWN CENTRE traffic scheme has been remodelled several times over the last century and has often been controversial. The Market Place was filled with parked cars until, in 1974, a central walled precinct with trees was constructed and named Falaise Square in honour of Henley's French twin town. Traffic on either side was excluded in January 1999, only to be partially readmitted in September 1999. The walls have since been removed to create an open paved area ideal for cafés and street markets, and for quiet relaxation.

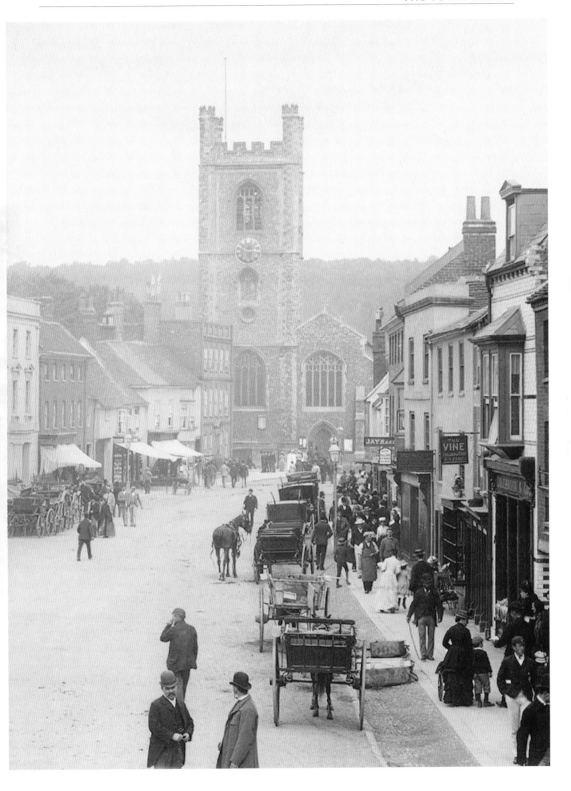

HART STREET,
NEAR THE BRIDGE

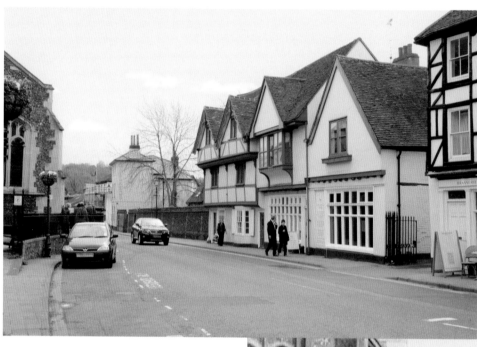

TOWARDS THE BRIDGE from Hart Street, *c.*1900 (right). The timber-framed houses with tall gables date from the seventeenth century, the furthest of them a particularly fine house with a double overhang, or 'jetty'. The nearer house is reputed to be the birthplace of William Lenthall, the famous speaker of the House of Commons who refused to admit Charles I in 1642. The houses have been converted to commercial premises, including a hairdressing and shampooing salon.
(Reproduced with kind permission of Bushells Photographic)

THE GABLED HOUSES have been well restored and painted and the Georgian building nearest

to the camera has acquired some bogus timbering and is now a brasserie restaurant. Medieval houses and a town cross once stood in the centre of Hart Street, causing major congestion for traffic approaching the bridge. They were removed in the 1760s, and the road past St Mary's church was further widened in the 1780s, although it remains narrow for modern traffic. The Angel on the Bridge inn, swathed in scaffolding, can be seen in the distance.

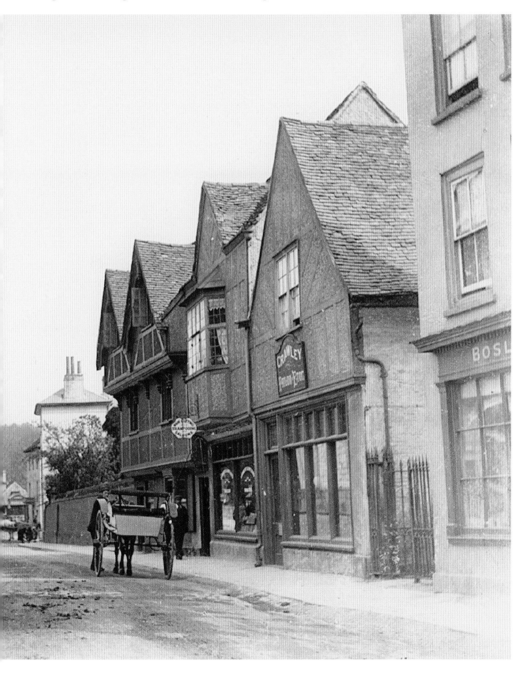

THE CHANTRY HOUSE

THE DELIGHTFUL CHANTRY House next to St Mary's churchyard is probably the oldest
timber-framed building in Henley. Because of the slope of the land, the three-storey building

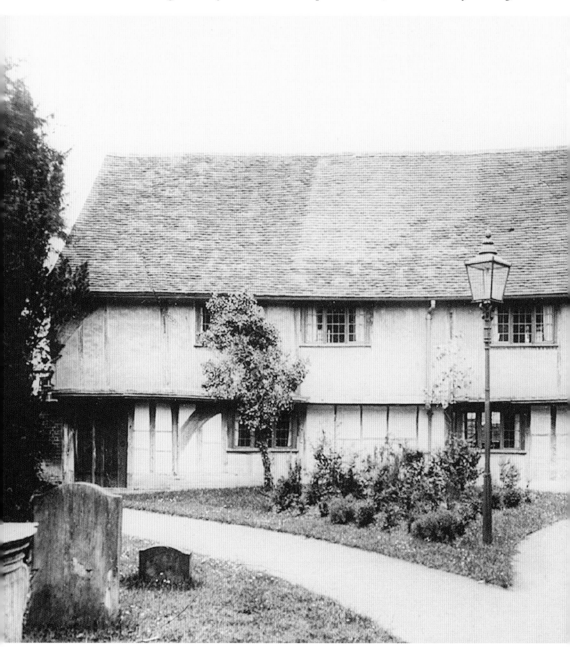

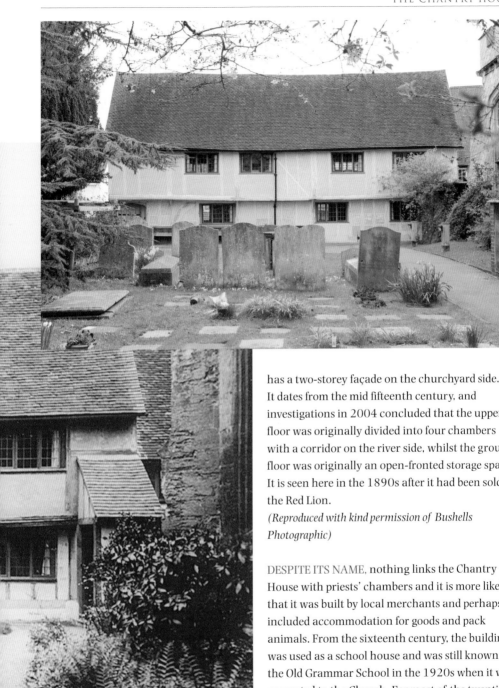

has a two-storey façade on the churchyard side. It dates from the mid fifteenth century, and investigations in 2004 concluded that the upper floor was originally divided into four chambers with a corridor on the river side, whilst the ground floor was originally an open-fronted storage space. It is seen here in the 1890s after it had been sold to the Red Lion.
(Reproduced with kind permission of Bushells Photographic)

DESPITE ITS NAME, nothing links the Chantry House with priests' chambers and it is more likely that it was built by local merchants and perhaps included accommodation for goods and pack animals. From the sixteenth century, the building was used as a school house and was still known as the Old Grammar School in the 1920s when it was presented to the Church. For most of the twentieth century it was covered with cement render, which was removed in 2004 following extensive restoration to reveal the original timber frame and brick infill panels.

No. 16 Hart Street

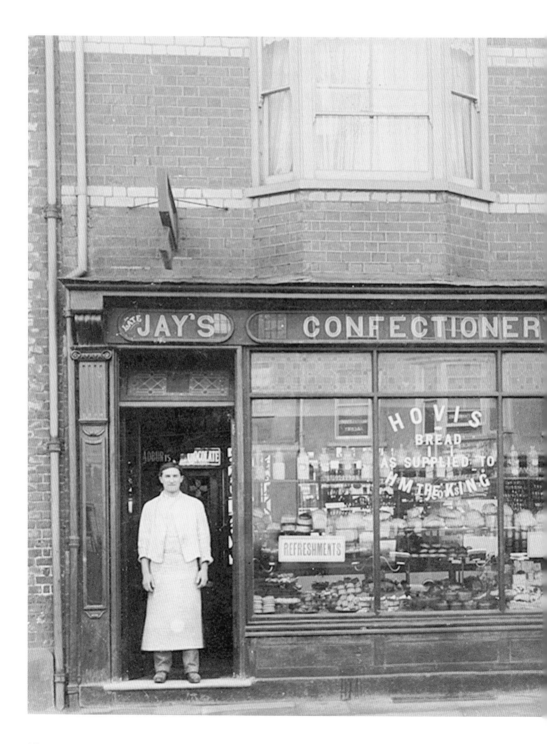

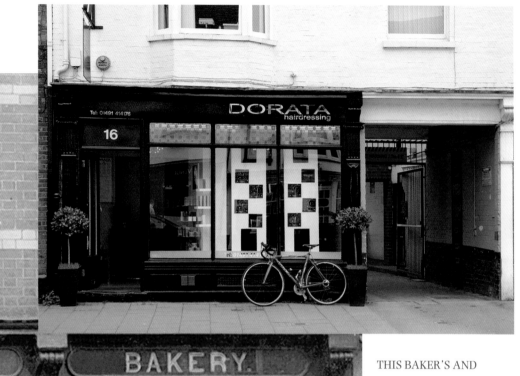

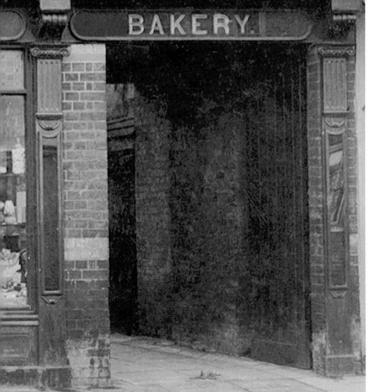

THIS BAKER'S AND confectioner's shop at No. 16 Hart Street has a window display very typical of its era, *c.*1910 (left). It was for some years run by George Jay and in 1911 became Hughes Bros dairy. *(Reproduced with kind permission of the* Henley Standard*)*

ALTHOUGH THE BUILDING has been painted white and the shopfront black, the building itself is little changed. The nature of the business is, however, very different, a fashionable hairdressing salon having replaced the bakery in this prime retail location.

NO. 18 HART STREET

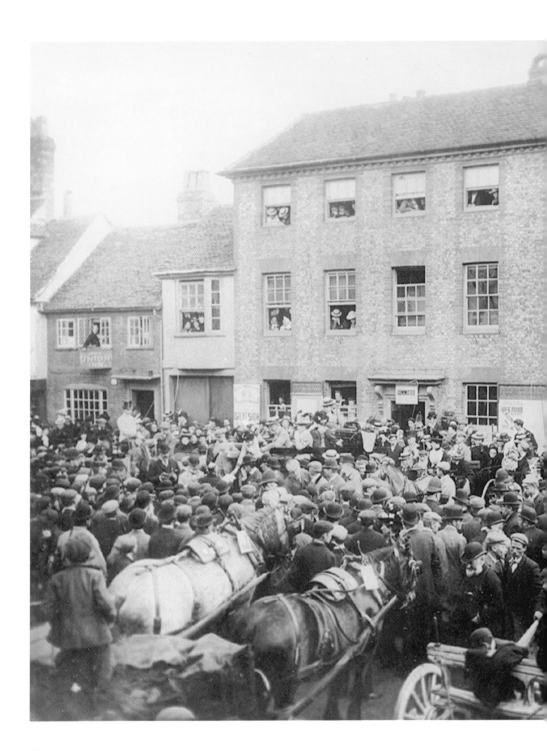

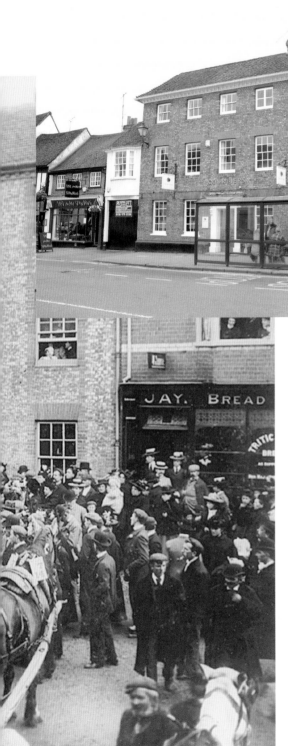

HART STREET PACKED with people attending an agricultural fair and sale *c.*1900 (left). This was an annual event, and horses for sale were trotted up and down for viewing. Attention is focused on the premises of Simmons and Sons, auctioneers, valuers and land agents, but it appears that the bidding has not yet begun. *(Reproduced with kind permission of Bushells Photographic)*

SIMMONS AND SONS later moved from Hart Street and split into two businesses, one of which still trades under its original name in Bell Street. No. 18 Hart Street served as an antiques shop for many years and is now the offices of Courtiers. The building displays some fine Georgian brickwork – most of the wall is in grey brick but the windows are joined vertically in red brick, which continues over the window tops. It might have been built as a house for a wealthy maltster, because part of an eighteenth-century malting floor survives behind it.

LOOKING TOWARDS
THE TOWN HALL

LOOKING TOWARDS THE town hall *c.*1880. Alderman Bradshaw demolished the market house, guildhall and gaol in 1795 and replaced them with this town hall, which he designed himself.

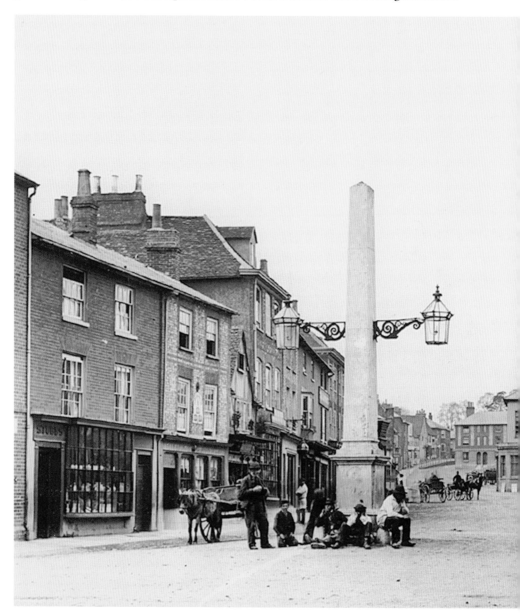

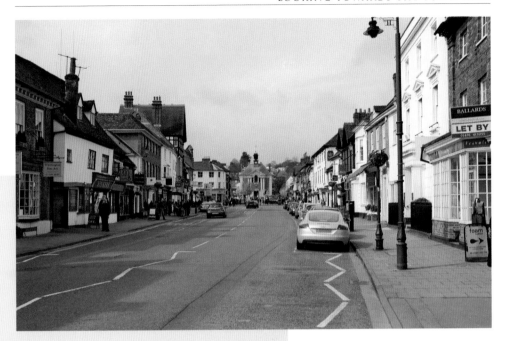

The ground floor was originally open for use as a grain market but was later enclosed to make extra office accommodation. The obelisk in the foreground was put up as a milestone in the 1780s at the crossroads of Hart Street and Bell Street, and three of its sides were inscribed with the distances to Reading, Oxford and London. *(Reproduced with kind permission of Bushells Photographic)*

THE SAME VIEW today looking towards the 'new' town hall (above), which was completed in 1901. Designed by H.T. Hare to mark the Queen's Diamond Jubilee in 1897, it is one of Henley's grandest buildings and expresses the town's self confidence in the late Victorian era. The tall Tudor-style building that dominates the street on the left-hand side was built as the London and County Bank in 1892.

17

THE TOWN HALL

THE TOWN HALL being used as a military hospital during the First World War (below). The Red Cross laid out twenty-four beds on the upper floor in August 1914 and the first patients arrived in October to be nursed by the Henley Voluntary Aid Detachment. The cost was met by local benefactors, including Robert Brakspear.

(© River and Rowing Museum, Henley-on-Thames)

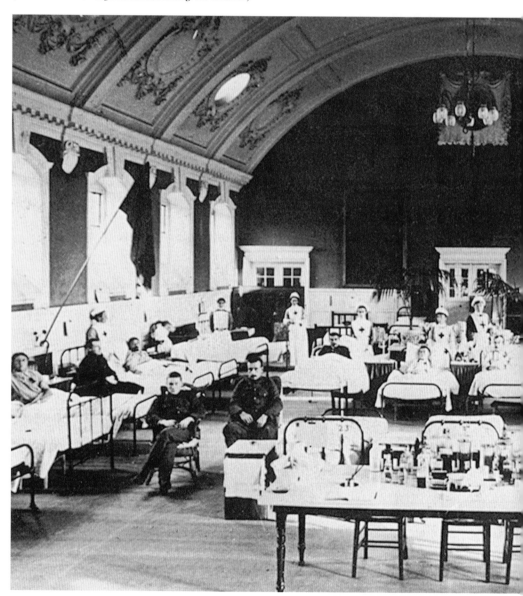

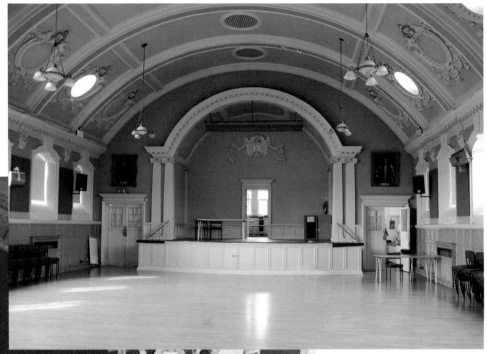

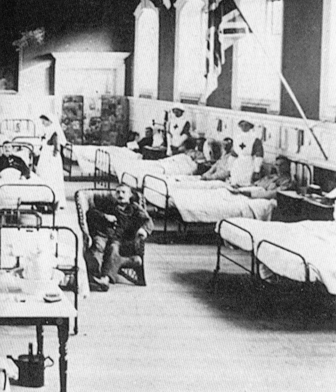

THE PUBLIC HALL on the upper floor of the town hall today, showing a rich display of baroque plasterwork. H.T. Hare had recently completed the new 'Jacobean' town hall in Oxford, but here he uses a Queen Anne style to reflect Henley's early eighteenth century architecture. Henley's first public library was opened in the town hall, initially run by a Red Cross librarian but later taken over by the borough council. In 1981 a new library was built by Oxfordshire County Council near the present Waitrose supermarket.

GABRIEL MACHIN'S BUTCHERS

GABRIEL MACHIN'S BUTCHERS shop in the Market Place, photographed in the 1950s (below). Machin traded in the Market Place as a poulterer and pork butcher from the 1880s

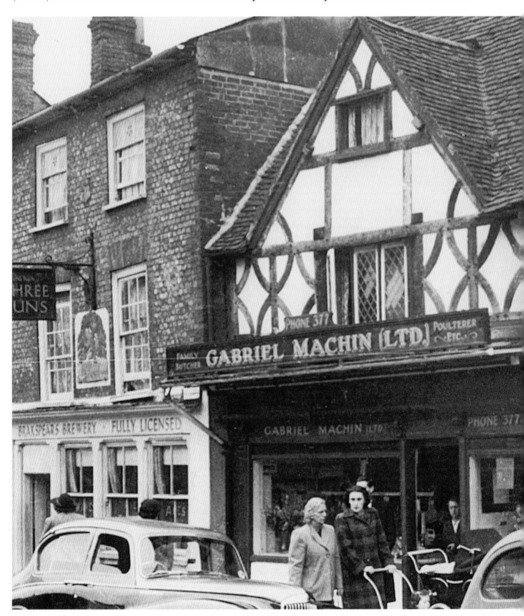

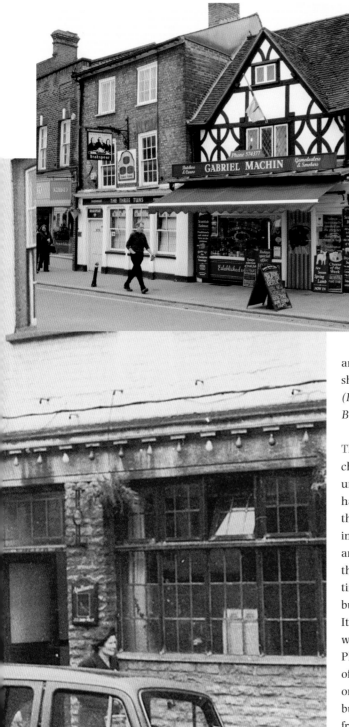

and the family also ran a grocer's shop in Northfield End.
(Reproduced with kind permission of Brakspear Pub Company)

THE BUTCHER'S SHOP has now changed ownership but still trades under the name of Machin and has competed successfully with the supermarkets by specialising in unusual and high quality meat and fish. The photograph shows the early seventeenth-century timber framing well, but the building behind it is much older. It is a long and narrow building with its gable facing the Market Place, and this is typical of many of Henley's medieval houses built on 'burgage plots'. They were built in this way because the street frontage was the most sought-after and expensive land.

HART STREET,
NEAR THE CROSSROADS

A BUSY DAY in Hart Street in the early twentieth century, with the new town hall in the distance (below). The old town hall (see p.16) was taken down in 1898 and re-erected on Crazies Hill as a private house. Its replacement, completed in 1901, satisfied the corporation's need for extra office accommodation and was designed by Henry T. Hare.

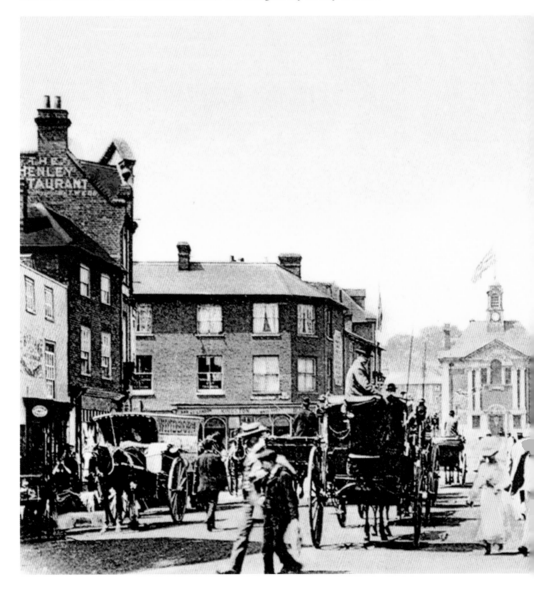

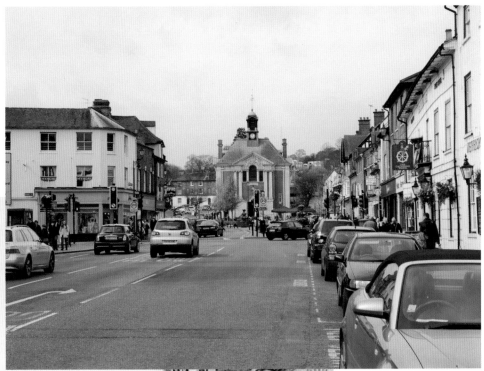

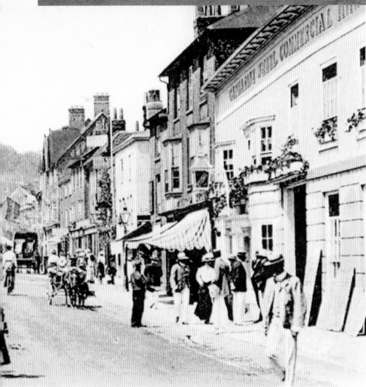

A SIMILAR SCENE today (above), with traffic-filled Hart Street and the paved Market Place beyond. There was originally a block of buildings in the centre of the Market Place known as Middle Row, which incorporated a medieval guildhall. The guildhall, a late fifteenth-century timber-framed building, incorporated a first-floor council chamber with a cupola above and a kitchen below. It survived until the 1790s when Middle Row was swept away to create a large open space in front of the town hall.

AT THE CROSSROADS

LOOKING INTO BELL Street in about 1900, with the Market Place to the left and Hart Street to the right. At the crossroads stands a drinking fountain and behind it can be seen the premises

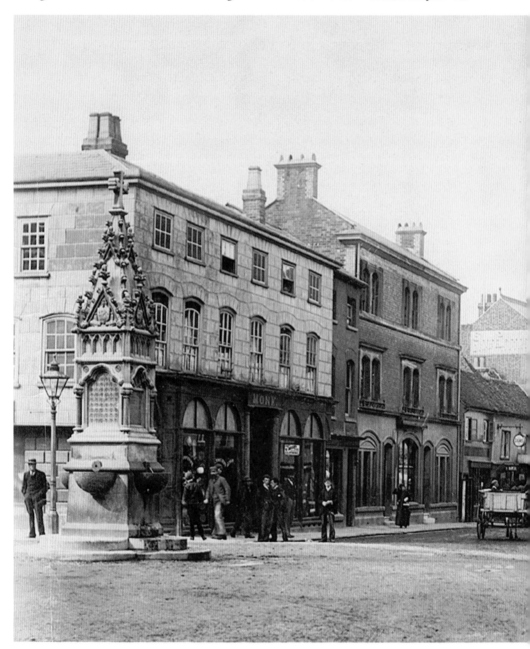

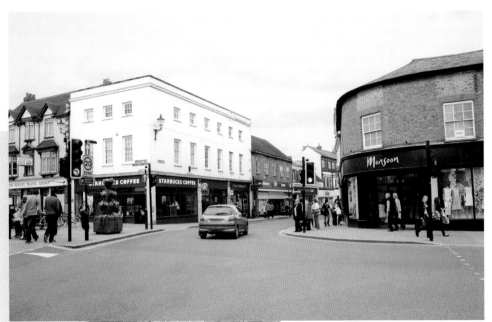

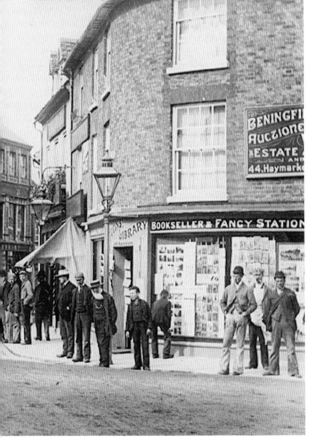

of Monk and Sons, a drapery store founded by Charles Monk before 1883. On the other corner is S.H. Higgins', bookseller and newsagent, which before the First World War became Timothy White, cash chemists.

MONK AND SONS closed in the 1950s and the site is now occupied by Starbucks Coffee shop and Boots the chemist. The building on the opposite side of the road has been reduced in height and now trades as Monsoon clothes shop. The junction has been made easier for traffic by the removal of the water fountain to a more convenient position in front of the west door of St Mary's church. The fountain, in porphyry and stone with a crocketed spire, was erected to the memory of Greville Phillimore, rector of Henley from 1867 to 1883, who earned the gratitude of the town for his numerous benefactions.

BELL STREET

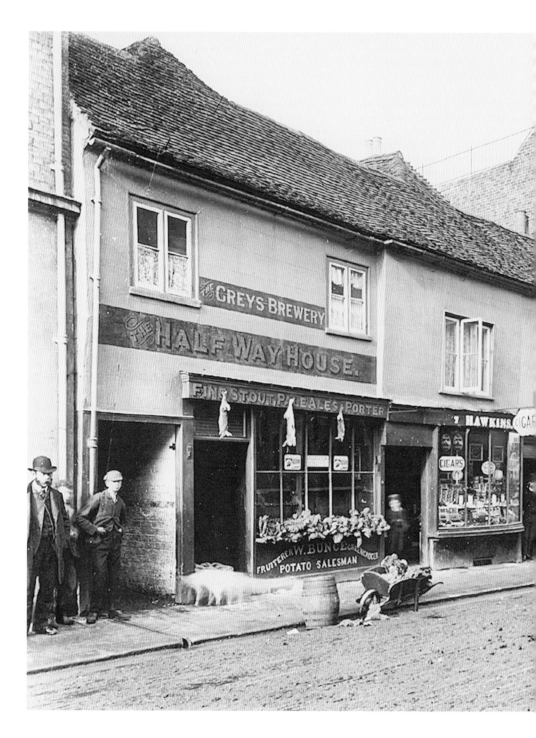

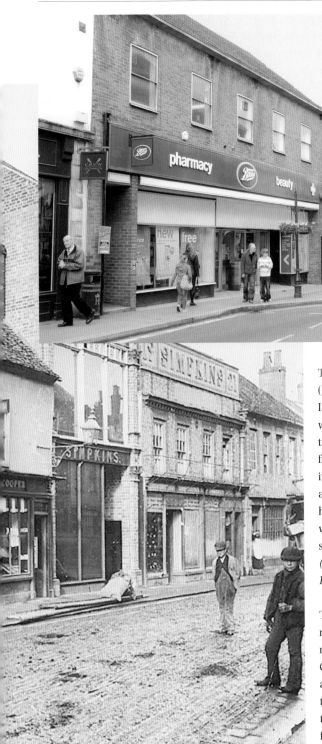

THE VIEW OF Bell Street in the 1890s
(left) shows a delightful variety of shops.
In the foreground, the Halfway House
was run by publican W. Bunce and seems
to sell everything from ales and porter to
fruit, vegetables and even rabbits! Beyond
it can be seen a tobacconist, a fruiterer
and William Simpkins' drapery and
haberdashery store with its large shop
windows. The road itself looks dirty and
splattered with horse dung.
*(Reproduced with kind permission of
Bushells Photographic)*

THE HALFWAY HOUSE and its
neighbour have been demolished and
replaced by Boots and Sainsbury's, and
Clinton Cards now occupies the much
altered premises of Simpkins. Attempts at
traffic calming have been introduced but
this narrow street remains a busy route
for through traffic. It does, however, look
much cleaner!

No. 33 Bell Street

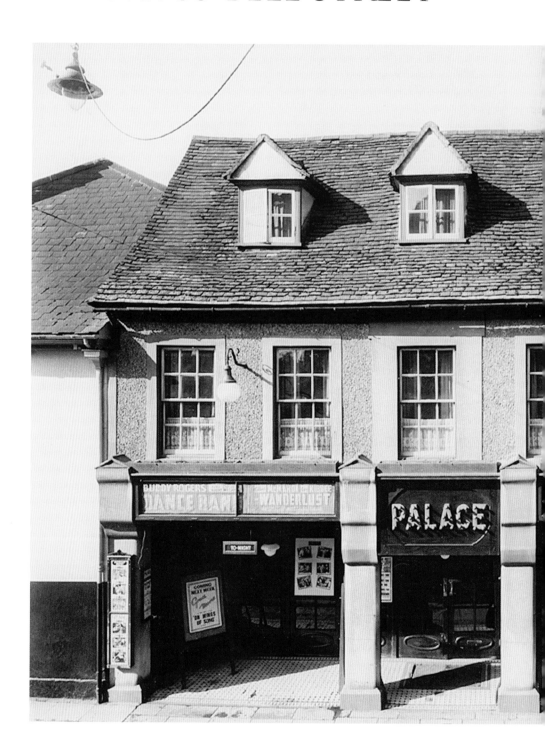

HENLEY'S PICTURE PALACE
cinema at No. 33 Bell Street, seen
in the old photograph on the left in
the 1920s. The cinema was opened
as early as 1911 in premises which
had been a rollerskating rink.
*(Reproduced with kind permission of
Bushells Photographic)*

IN 1937 THE Picture Palace was
pulled down to make way for the
Regal cinema, which boasted a fine
art deco interior with a Compton
organ. The organ was acquired by the
Henley and District Organ Trust in
1971. This cinema was demolished
in 1993 as part of the Waitrose
development. The development had
been six years in the planning, during
which a vigorous 'save the Regal'
campaign had been fought. The town
now has a new cinema as well as a
restored Kenton Theatre.

FURTHER ALONG
BELL STREET

BELL STREET LOOKING north, *c.*1895 (below). On the left can be seen Alfred Pither's butchers, famous for its home-cured hams and 'celebrated Henley sausages' and beyond it are Henry Crocker's shoe shop and the Bull inn with its projecting lamp.

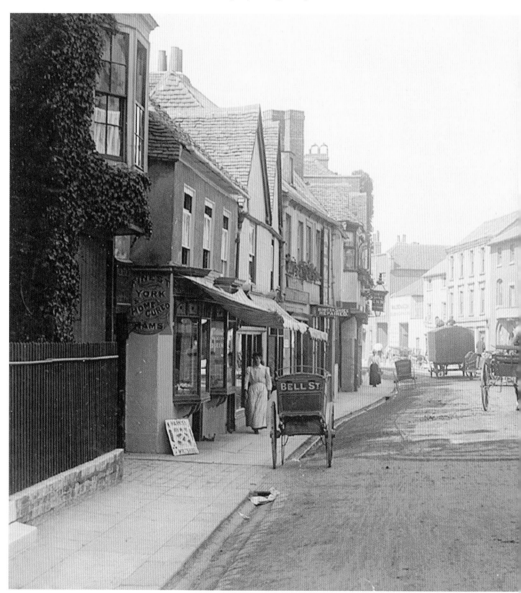

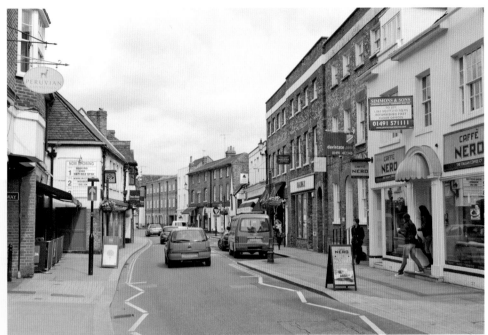

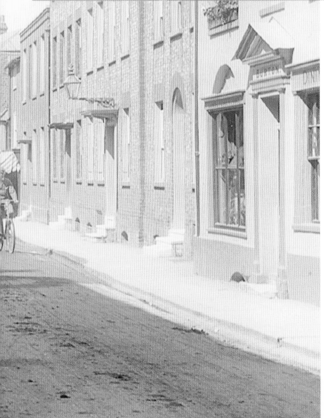

AS CAN BE seen in the 2011 photograph above, much of the left-hand side of the street has been rebuilt as part of the Waitrose development. A hanging sign further down on the left reading 'Ko-Ko Cocktail Bar Club' indicates the present use of the Bull inn. The Bull was one of Henley's great medieval inns, and it had three large glazed windows added on the first floor in the seventeenth century. The Bull later became a coaching inn. On the other side of the road the changes are limited mainly to the shopfronts; Burton dining rooms on the right is now the Caffè Nero.

31

NORTHFIELD END

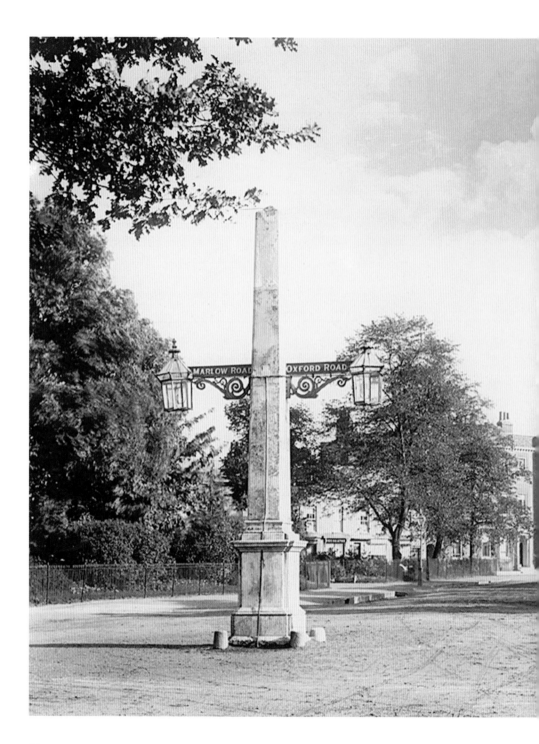

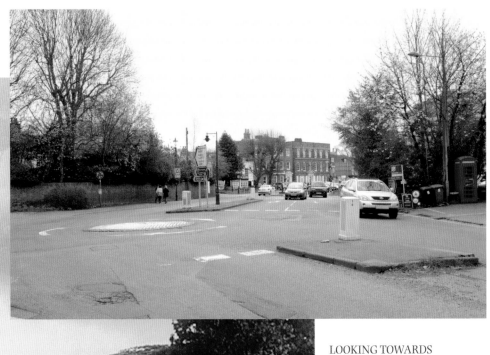

LOOKING TOWARDS
NORTHFIELD End in 1892 (left).
The obelisk was moved to the
fork of the Marlow and Oxford
roads from the town centre in
1885 and converted for use as
a signpost. It originally stood in
Market Place (see p.16).

IN 1970 THE obelisk was moved
again, this time to Mill Meadows,
and a mini-roundabout has
replaced it at Northfield End.
This is the entrance to Henley
from the 'Fair Mile', a wide
avenue of elm trees planted
by Sir Thomas Stapleton, Lord
of the Manor of Benson, in
1751 and since replanted with
oaks and limes. The Fair Mile
remains one of Henley's great
assets and on the whole modern
development has not been
allowed to encroach on it.

DUKE STREET

A VIEW OF Duke Street in the 1860s (below). This was a poor part of town made up of small cottages, often with 'jettied' or overhanging upper storeys. The street was exceptionally narrow and inconvenient for traffic and, like many of the streets in Henley, was muddy in winter and clogged with horse dung throughout the year.

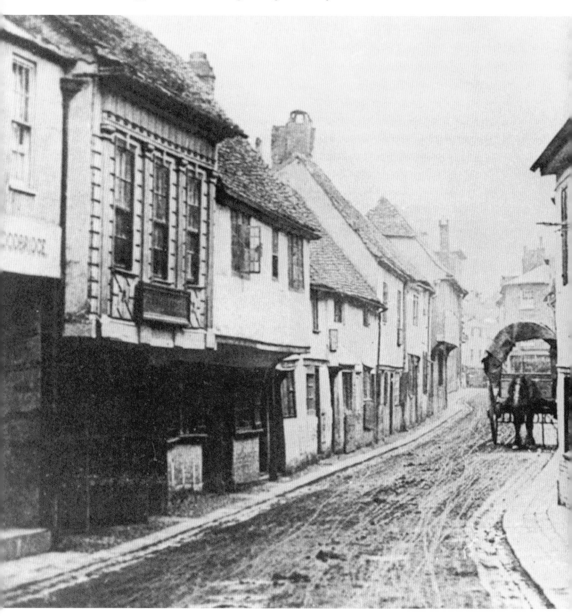

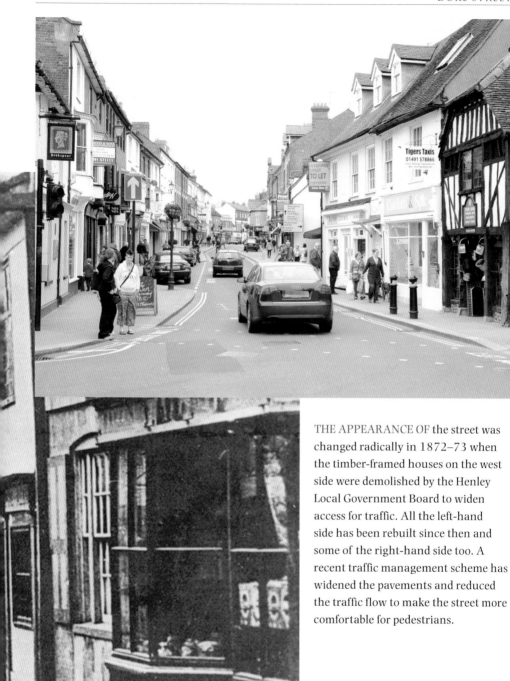

THE APPEARANCE OF the street was changed radically in 1872–73 when the timber-framed houses on the west side were demolished by the Henley Local Government Board to widen access for traffic. All the left-hand side has been rebuilt since then and some of the right-hand side too. A recent traffic management scheme has widened the pavements and reduced the traffic flow to make the street more comfortable for pedestrians.

HAWKINS,
No. 11 DUKE STREET

QUEEN MARY VISITING the premises of John Hawkins, fine china and glass dealer, at Nos 7–11 Duke Street in the 1920s (below). Queen Mary, the consort of King George V, was a renowned art connoisseur and needlewoman, and she built up a fine collection of tableware and antiques. She visited this shop on several occasions.
(Reproduced with kind permission of Bushells Photographic)

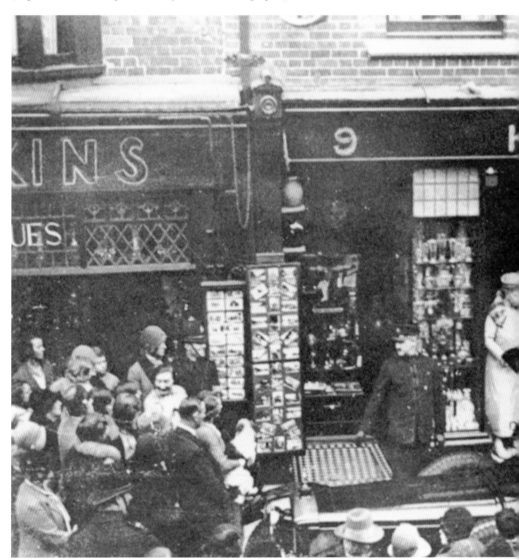

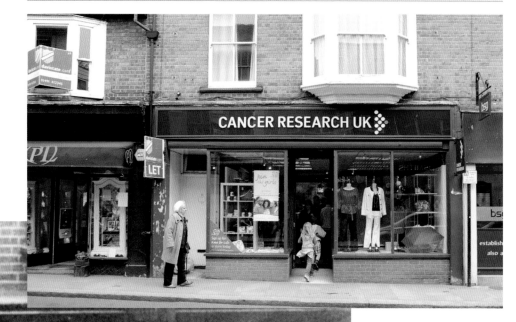

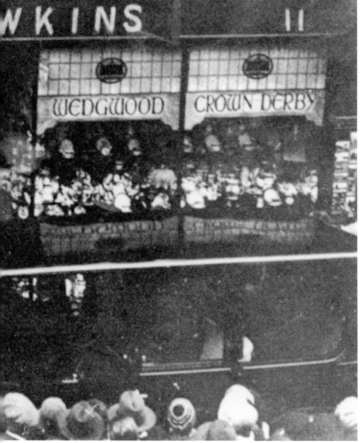

HAWKINS' SHOP CONTINUED in business until 1950. Since then, No. 11 Duke Street has been occupied by a succession of shops, including the Imperial Cancer Research Fund and now Cancer Research UK. The building itself is little changed, although sadly it has lost its attractive shopfront.

THE UNITED REFORMED CHURCH AND CAXTON HOUSE

THE CONGREGATIONALIST CHURCH, as it was then called, and Caxton House at the junction of Reading Road and Station Road in about 1910 (below). Thomas Higgs moved his printing

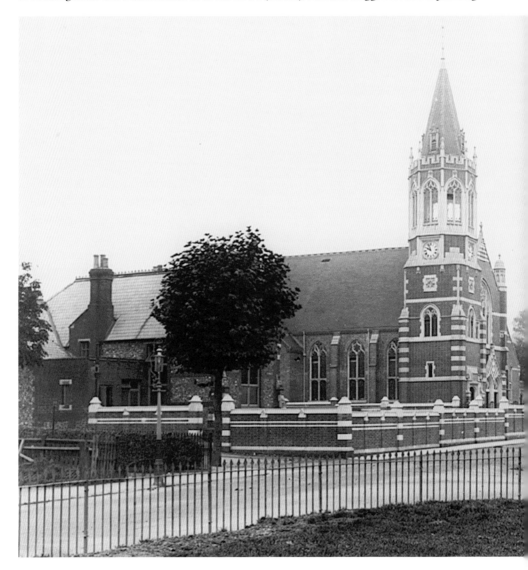

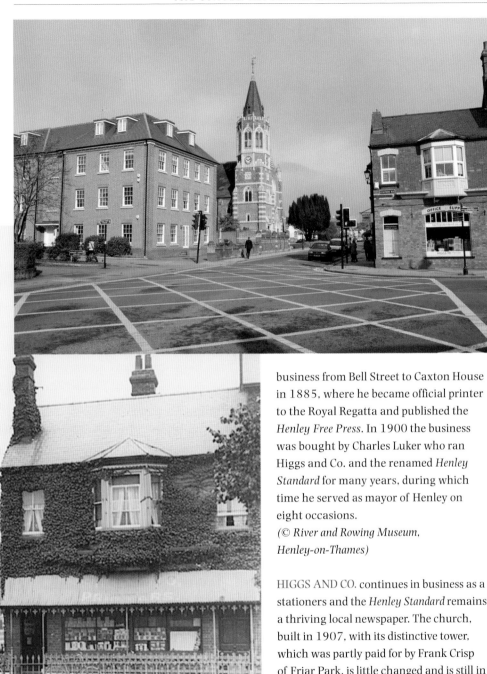

business from Bell Street to Caxton House in 1885, where he became official printer to the Royal Regatta and published the *Henley Free Press*. In 1900 the business was bought by Charles Luker who ran Higgs and Co. and the renamed *Henley Standard* for many years, during which time he served as mayor of Henley on eight occasions.
(© River and Rowing Museum, Henley-on-Thames)

HIGGS AND CO. continues in business as a stationers and the *Henley Standard* remains a thriving local newspaper. The church, built in 1907, with its distinctive tower, which was partly paid for by Frank Crisp of Friar Park, is little changed and is still in use as the United Reformed church, but the road junction has been opened up and the green and its railings removed. Opposite Higgs & Co. stand the Norman House apartments, erected in 2006.

THE BRIDGE

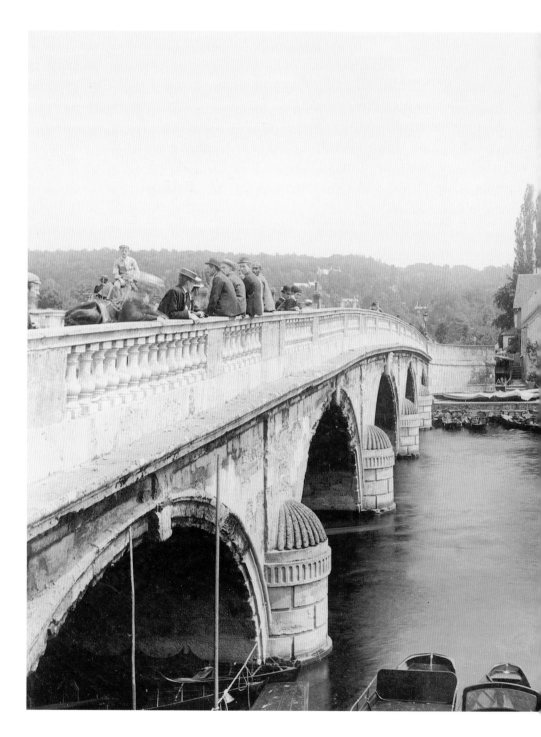

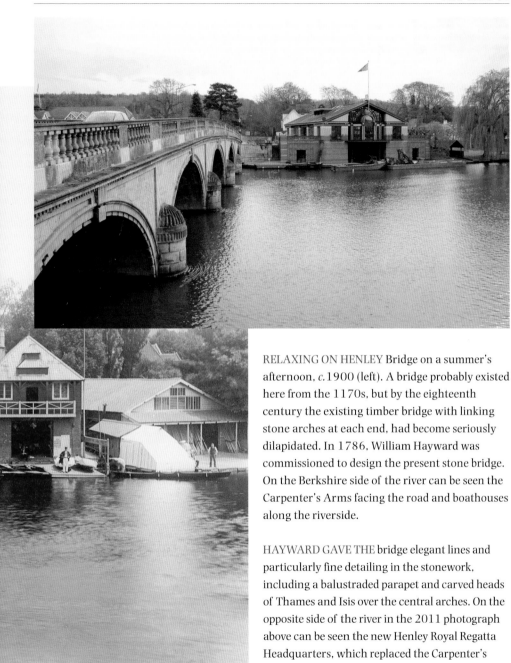

RELAXING ON HENLEY Bridge on a summer's afternoon, *c.*1900 (left). A bridge probably existed here from the 1170s, but by the eighteenth century the existing timber bridge with linking stone arches at each end, had become seriously dilapidated. In 1786, William Hayward was commissioned to design the present stone bridge. On the Berkshire side of the river can be seen the Carpenter's Arms facing the road and boathouses along the riverside.

HAYWARD GAVE THE bridge elegant lines and particularly fine detailing in the stonework, including a balustraded parapet and carved heads of Thames and Isis over the central arches. On the opposite side of the river in the 2011 photograph above can be seen the new Henley Royal Regatta Headquarters, which replaced the Carpenter's Arms and the boathouses in 1986. Designed in a post-modernist style by Sir Terry Farrell, it incorporates a club room at the front with a boathouse underneath and uses traditional brick in a gabled façade, with the addition of bright colours to express a new vitality.

APPROACHING HENLEY
FROM THE BRIDGE

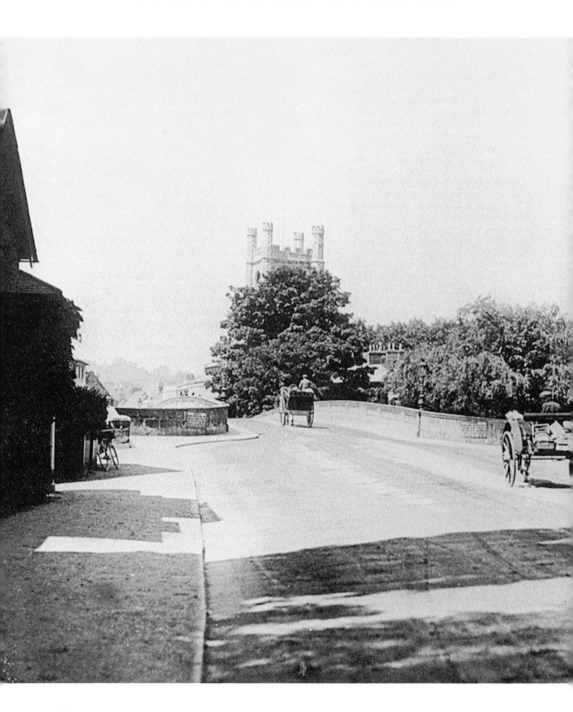

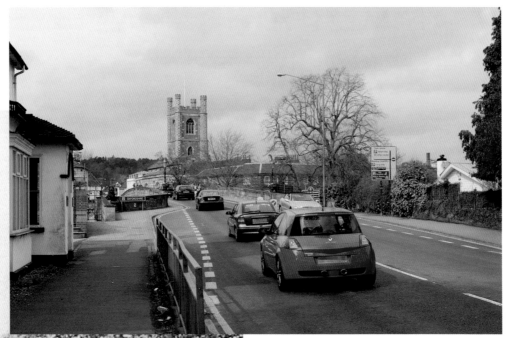

THE ENTRANCE TO Henley Bridge on the
Berkshire side was barred by a toll gate
until 1873, by which time the builders had
recouped the original £10,000 cost of the
bridge's construction. In this photograph
of about 1900 (left) the progress of the
carts towards Henley is unimpeded, and the
leisurely pace of the traffic means that keeping
to the left is not essential!

ROADMARKINGS DOMINATE THE view
today but little else has changed except for the
demolition of Toll Gate Cottage on the right in
the 1960s. The Royal Regatta Headquarters
can be reached on the left, and on the right,
a side road leads down to the Leander Club
and the riverside meadows. The Leander
Club was founded in 1818 and is Britain's
oldest surviving rowing club, whose members
include many distinguished rowers and those
who have served in the world of international
rowing. In 1897 the club built its permanent
riverside home in Henley.

THAMESIDE
AND FRIDAY
STREET

TIMBER-FRAMED FORMER granaries at the corner
of Thameside and Friday Street (right). Dating from
the early or mid sixteenth century, they are the
survivors of numerous granaries and warehouses
which once lined the riverside and served the town's
river trade. Large, flat-bottomed barges towed by
horses carried goods on the river; upstream from
London to Henley took about three days. By 1900,
when this picture was taken, the trade had all but
collapsed and the buildings appear to be in a poor
state of repair.

(Reproduced with kind permission of Bushells Photographic)

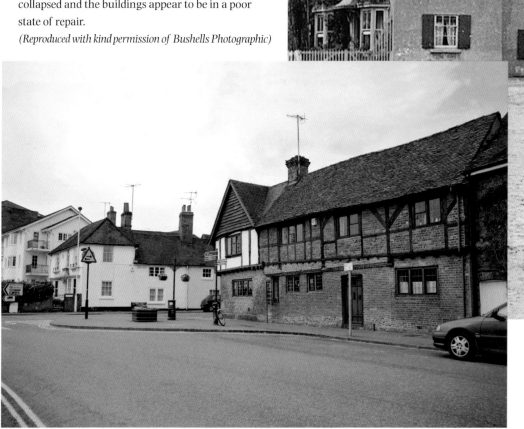

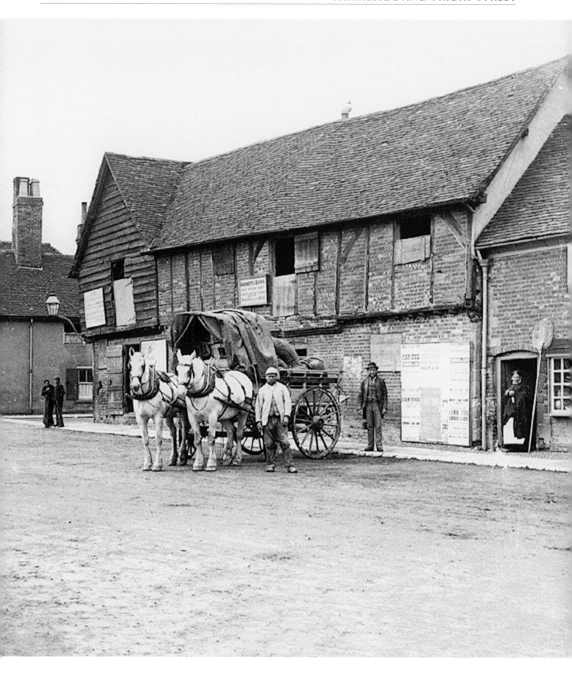

THE TIMBER-FRAMED buildings have since been converted into very desirable residences. The white rendered house to the left of the modern photograph is known as Baltic Cottage and was built in 1438 with a large central hall open to the rafters, and it retains much of its original fabric and a later central chimney stack. Like many of the oldest buildings in Henley, a later exterior conceals a much older construction behind.

FRIDAY STREET

FRIDAY STREET IN this photograph of about 1887 (right) presents a scene of picturesque dilapidation! This was the industrial end of town, and Grey's Brewery, an ironworks and a printing works could be found in the near vicinity. Despite the prosperity of the town, overcrowded slums divided by narrow alleyways, often with dark yards behind, could be found in many areas, often without fresh water or sanitation. A local sanitary board was established in 1864 and new regulations, slum clearances and road widening began in the succeeding decades.

MUCH OF FRIDAY Street was condemned for demolition in the 1930s but was

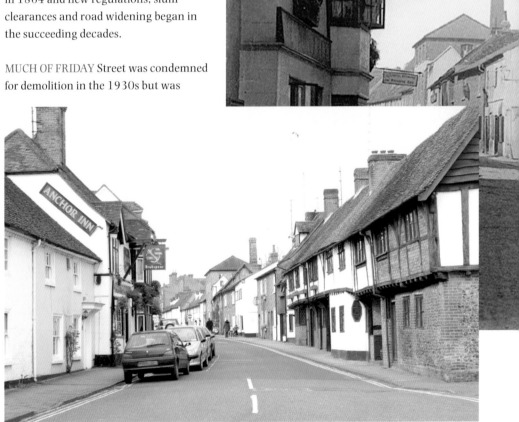

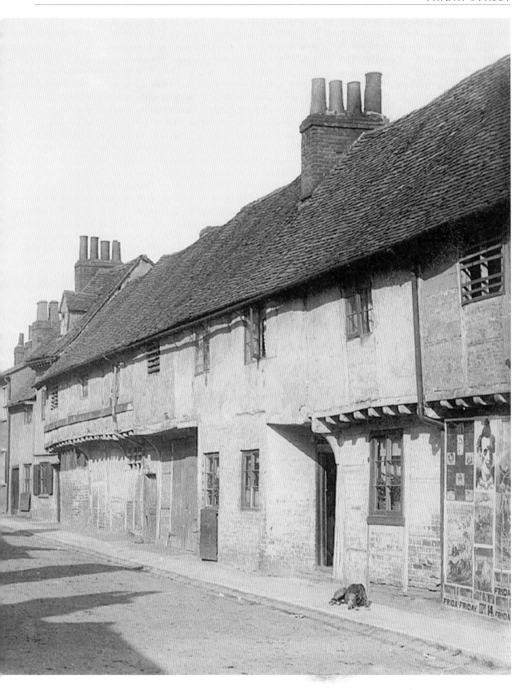

saved by the outbreak of war in 1939. The houses have since been restored and converted into attractive dwellings. Many of them have medieval origins, although refaced in the eighteenth century, such as Nos 17–29 on the right. The Anchor Inn is still in business, though no doubt serving a more prosperous clientele.

RIVERSIDE

RIVERSIDE SEEN FROM the bridge in the 1920s.
The arched entrance to the Red Lion Hotel stable
block can be seen on the left with a charming
riverside lawn in front of it, and beyond are the Red
Lion boathouses. The lawn was a favoured place to
watch the regatta, and originally the racecourse
started at Temple Island and finished here. Less
seemly were the brawls that sometimes took place
between the boatmen on Riverside; half a dozen
boat hire firms operated between the bridge and
Wharfe Lane and the rivalry between them was
often anything but friendly!

SADLY, PART OF the Red Lion Hotel's lawn was lost
to road widening when the one-way system was
introduced and teas are no longer served there. The
former granaries, boathouses and boat-building
premises in the centre have now been converted into

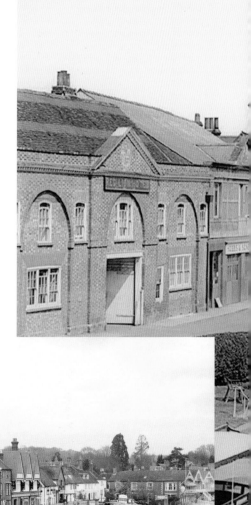

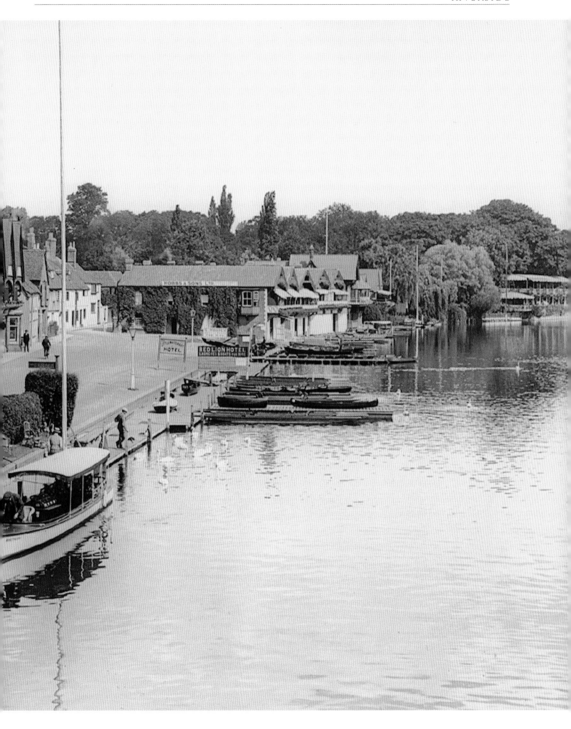

shops, and the tall gabled building, once the Little White Hart inn, is now used by the Henley United Rowing Club.

NEW STREET

BEFORE THE RIVER was brought under control in the twentieth century, Henley used to suffer from frequent flooding, and the severity of the 'Great Flood' of 1894 can be judged from this view from New Street towards the river. The picture also shows some of Henley's most elegant early eighteenth-century houses, and on the right one of the town's gas lights is nicely silhouetted.
(Reproduced with kind permission of Bushells Photographic)

THE HOUSES ON the left have not changed their outward appearances except for the replaced door canopy. Henley has some particularly fine classical houses, many with decorative brickwork in various shades of yellow, red and grey, and sometimes they are cut or 'rubbed' on window arches, pilasters and cornices. The wooden cornices are particularly

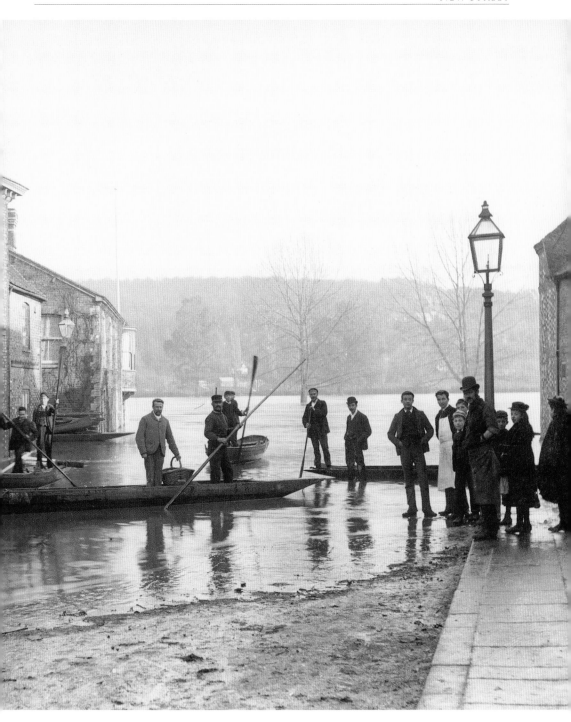

attractive here, but building regulations later outlawed them as a fire risk, so tall parapets were often used instead.

THE NATIONAL SCHOOL,
GRAVEL HILL

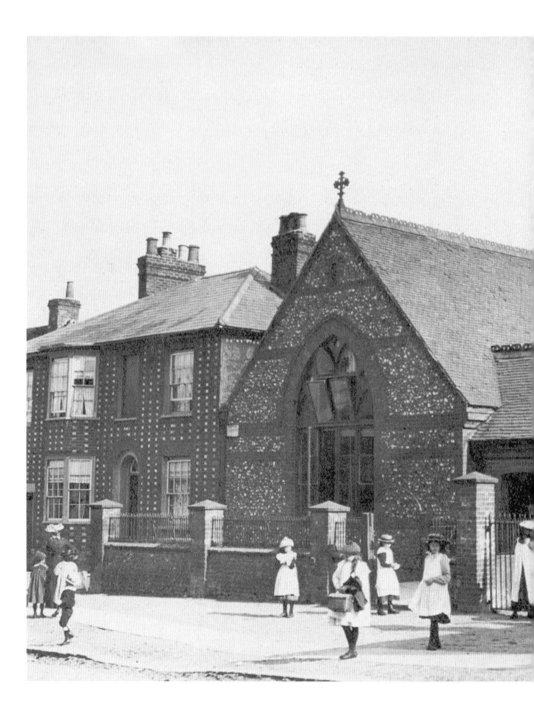

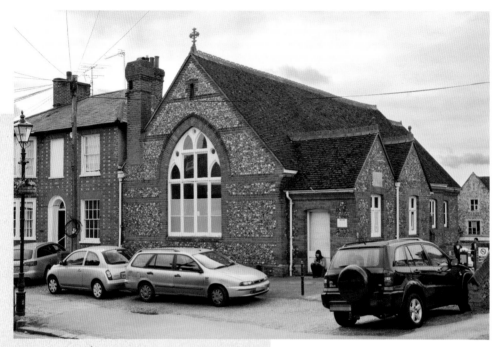

PUPILS AT THE National School, Gravel Hill, in 1904 (left). The National School accommodated 500 boys and girls, and included housing for the teachers. This schoolroom was for the girls and was built in 1879. National Schools insisted on Church of England denominational teaching, unlike the British schools, which were non-denominational. The latter were established by a voluntary organisation, the British and Foreign Schools Society, and there was one on Reading Road, which has now been demolished.

THE SCHOOL BUILDINGS are now used by Henley College but the character of the building has been preserved. The mixed flint and brick construction and tall gabled roof is a good example of Victorian 'vernacular' Tudor, intended to reflect the local building styles and materials of the Chilterns.

THE INFANTS' SCHOOL,
GRAVEL HILL

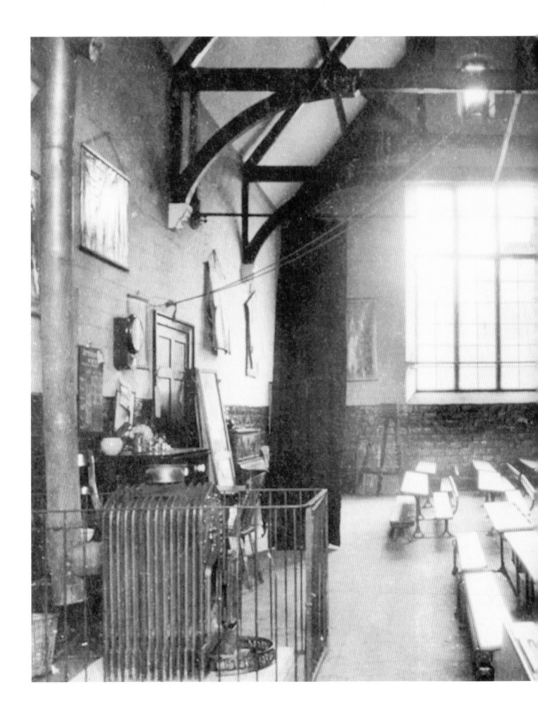

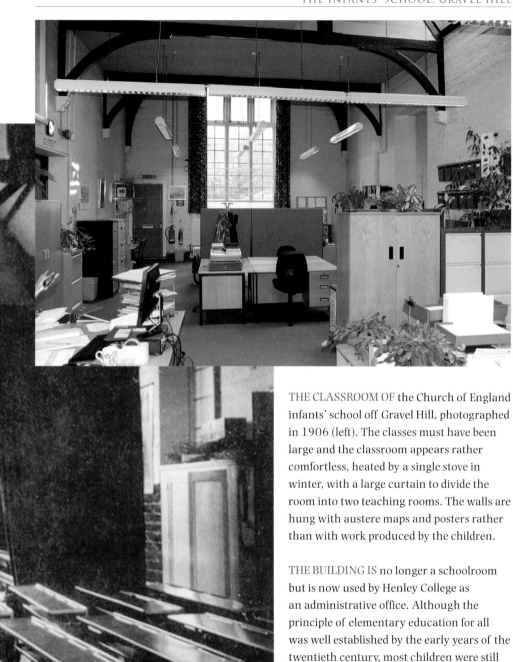

THE CLASSROOM OF the Church of England infants' school off Gravel Hill, photographed in 1906 (left). The classes must have been large and the classroom appears rather comfortless, heated by a single stove in winter, with a large curtain to divide the room into two teaching rooms. The walls are hung with austere maps and posters rather than with work produced by the children.

THE BUILDING IS no longer a schoolroom but is now used by Henley College as an administrative office. Although the principle of elementary education for all was well established by the early years of the twentieth century, most children were still denied a secondary school education unless they won a scholarship to a local grammar school. Henley is now well served by good schools, including Henley College, which occupies a large and well equipped campus on Deanfield Avenue.

THE FIRE STATION

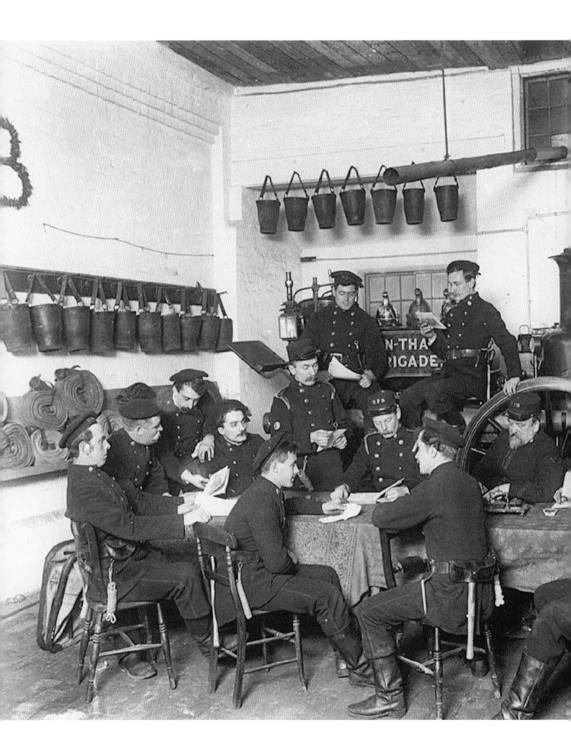

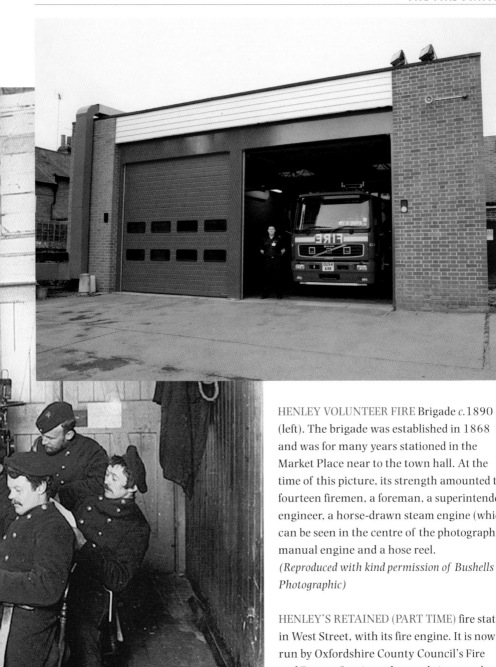

HENLEY VOLUNTEER FIRE Brigade *c.*1890
(left). The brigade was established in 1868
and was for many years stationed in the
Market Place near to the town hall. At the
time of this picture, its strength amounted to
fourteen firemen, a foreman, a superintendent
engineer, a horse-drawn steam engine (which
can be seen in the centre of the photograph), a
manual engine and a hose reel.
*(Reproduced with kind permission of Bushells
Photographic)*

HENLEY'S RETAINED (PART TIME) fire station
in West Street, with its fire engine. It is now
run by Oxfordshire County Council's Fire
and Rescue Service, whose role is not only
to respond to fires and emergencies but also
to work with community organisations and
partners to help prevent fires and emergencies
occurring. Its current campaign is 365 Alive,
which encourages people to 'think safety'.

THE BAKERY, MARKET PLACE

HALES AND SON Model Steam Bakery was founded at No. 20 Market Place by Stephen Hales and, according to an advertisement in 1906, sold 'Pure household bread, brown bread, Hovis bread, milk bread, Veda bread and Vienna bread'. The photograph on the right was taken about 1893.
(Reproduced with kind permission of Bushells Photographic)

A CORRESPONDING SCENE, from the Patisserie Franco-Belge in Duke Street (below). The equipment is now stainless steel, and cleanliness and hygiene are high

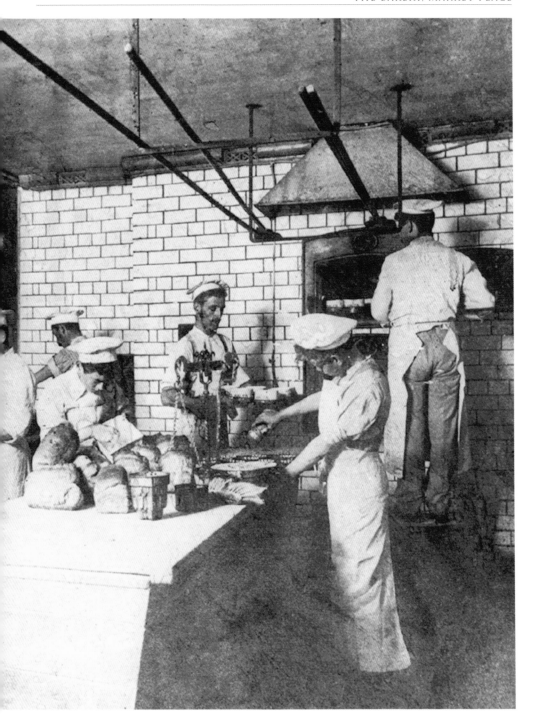

priorities, but bread continues to be made in the traditional way and no doubt the skills required of the baker are much the same as in Hales' time.

THE CHEMIST,
BELL STREET

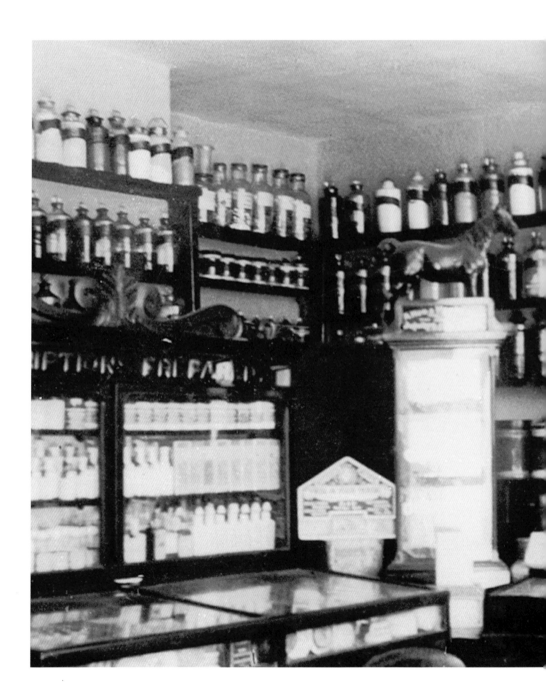

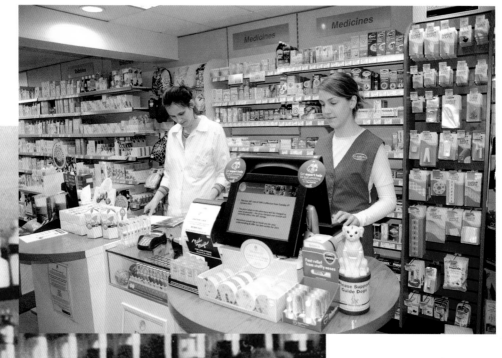

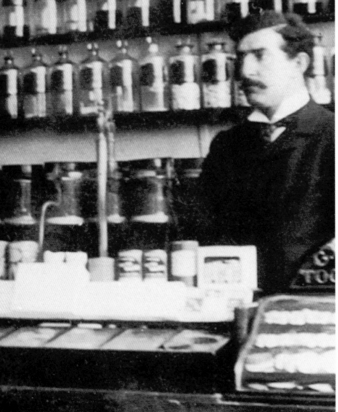

MR TURTON GREEN behind
the counter of his chemist's
shop in Bell Street, c. 1900
(left). The serried ranks of
dark bottles seem to lend an
air of fear and mystique to his
profession.

THE SALES AREA of
the Henley Pharmacy in
modern-day Bell Street gives
an altogether more welcoming
impression. Pharmaceutical
products are now mostly mass
produced and pre-packaged
rather than being made up
to order from their chemical
constituents. However,
they are undoubtedly much
safer than their Victorian
counterparts, which often used
substances such as arsenic as
active ingredients!

HENLEY POSTMEN

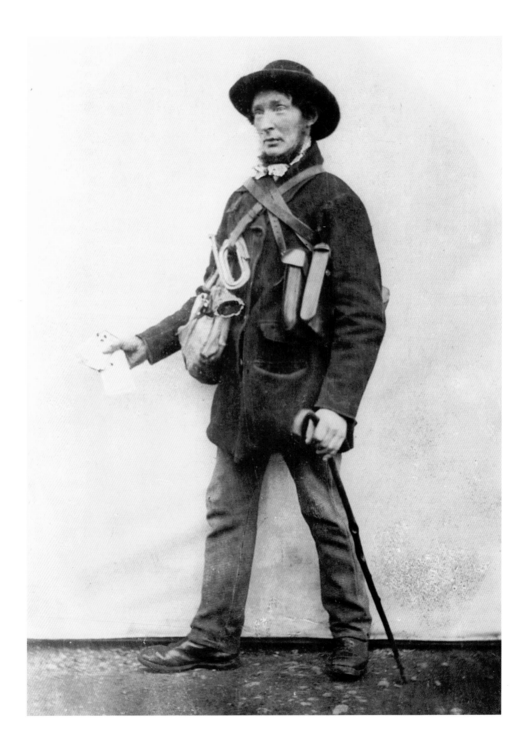

A RARE AND very early photograph of Henley's first postman (left), probably taken in about 1860. As well as his leather bags for carrying letters, he is equipped with a bugle and a walking stick. *(Reproduced with kind permission of Bushell's Photographic)*

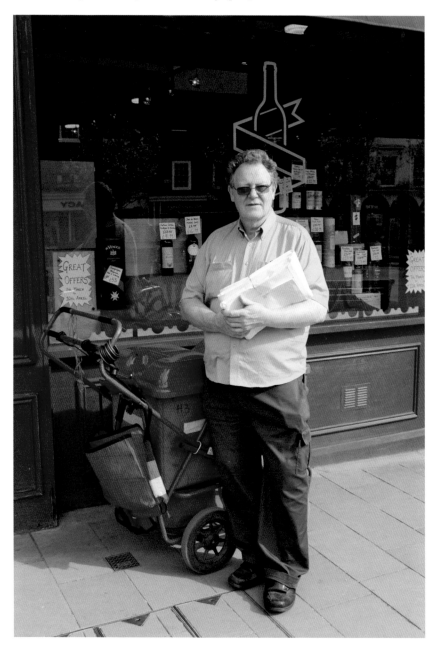

TODAY'S POSTMEN DRESS very differently and are given a trolley on wheels to carry their post instead of leather bags. Here Spirited Wines in the Market Place is about to receive its delivery.

THE BELL STREET
MOTOR WORKS

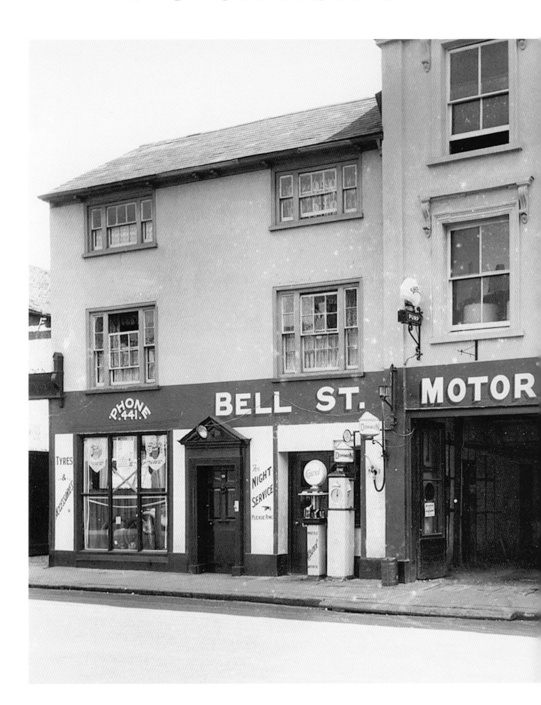

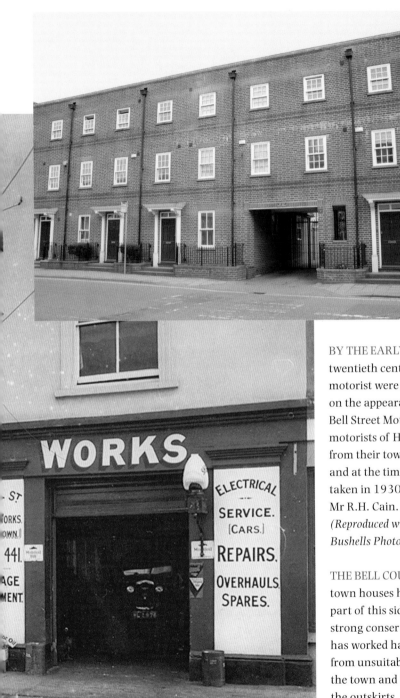

BY THE EARLY years of the twentieth century, the needs of the motorist were making an impact on the appearance of the town. The Bell Street Motor Works served the motorists of Henley for many years from their town centre premises, and at the time this picture was taken in 1930 it was being run by Mr R.H. Cain.
(Reproduced with kind permission of Bushells Photographic)

THE BELL COURT development of town houses has replaced a large part of this side of Bell Street. A strong conservation lobby in Henley has worked hard to protect the town from unsuitable development within the town and from expansion on the outskirts. Consequently, any surplus industrial land in prime locations such as this is eagerly snapped up for housing.

HOBBS AND SONS,
STATION ROAD

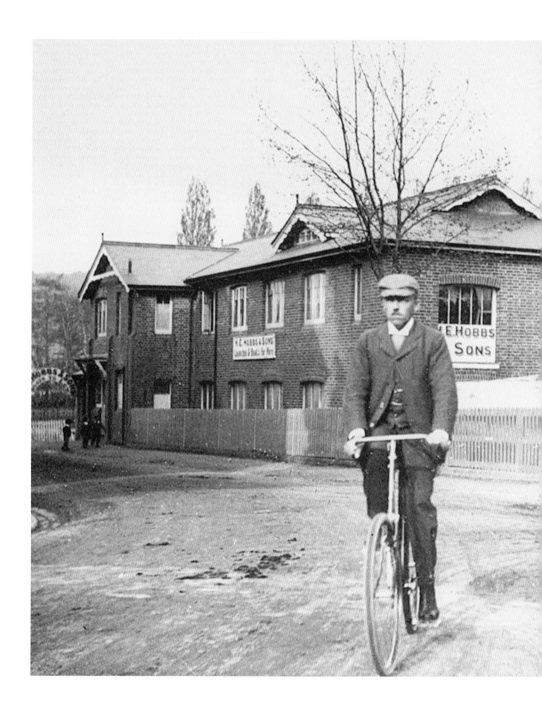

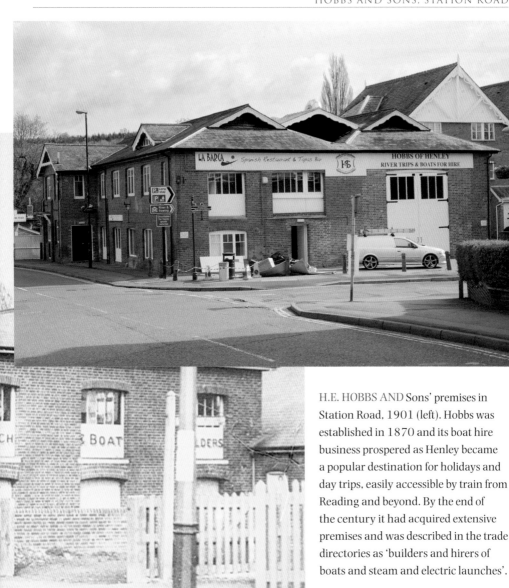

H.E. HOBBS AND Sons' premises in Station Road, 1901 (left). Hobbs was established in 1870 and its boat hire business prospered as Henley became a popular destination for holidays and day trips, easily accessible by train from Reading and beyond. By the end of the century it had acquired extensive premises and was described in the trade directories as 'builders and hirers of boats and steam and electric launches'.

HOBBS OF HENLEY still run river trips and hire out boats in the summer months from the same premises on Station Road. Boat builders and hirers, together with brewers, were the largest employers in nineteenth- and twentieth-century Henley; the town did not establish a substantial industrial base, unlike towns such as Banbury and Reading.

BRAKSPEAR'S BREWERY

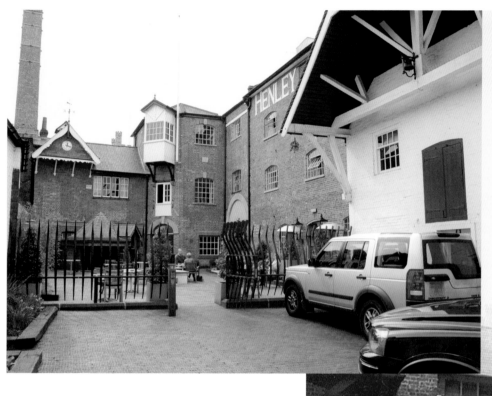

THE YARD AT Brakspear's brewery, New Street, with a horse-drawn dray about to depart, *c.*1900 (right). Henley was once renowned for its malthouses and breweries. Robert Brakspear opened his brewery in Bell Street in 1779 and in 1812 his son William took over these premises in New Street. The brewery in New Street had been built by Benjamin Sarney in the early eighteenth century, and the family also bought the house and malt kiln to the west, which later served as Brakspear's offices. The property was finally bought from Sarney's descendants by W.H. Brakspear and Sons in 1856.
(© River and Rowing Museum, Henley-on-Thames)

BRAKSPEAR'S BREWERY CLOSED in 2002 but continues as a pub-owning business. Much of Brakspear's office accommodation in New Street has been converted into hotel rooms for the Hotel du Vin, and the yard makes

an attractive outdoor drinking and dining area for the adjacent Bistro. The old buildings have, however, been preserved, including the brewery chimney, which was erected in 1865 when steam power was introduced.

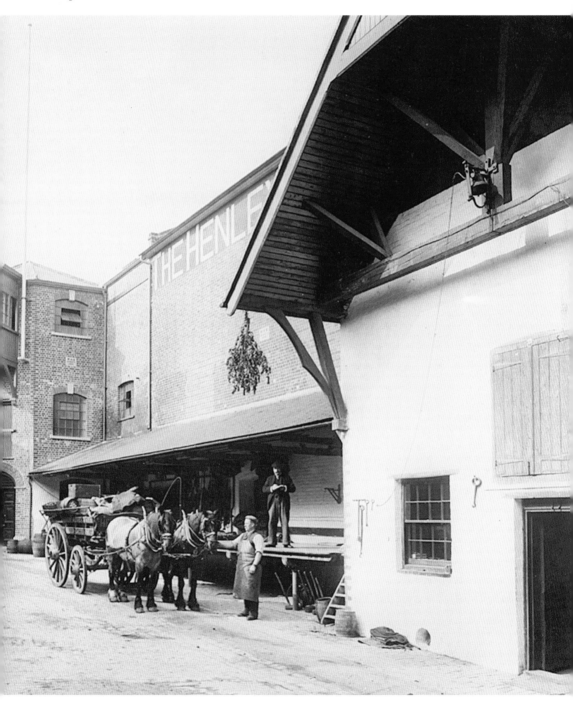

THE MALTHOUSES,
NEW STREET

GOOD QUALITY BARLEY grown around Henley was ideal for turning into malt for the breweries, and Pigot and Co.'s street directory of 1823 lists twelve maltsters in the town. Malting requires large heated growing floors on which the barley grains commence their germination, before they are transferred to the drying kilns and roasted. Brakspear's built these huge malthouses opposite their brewery in New Street in 1899, soon after taking over their

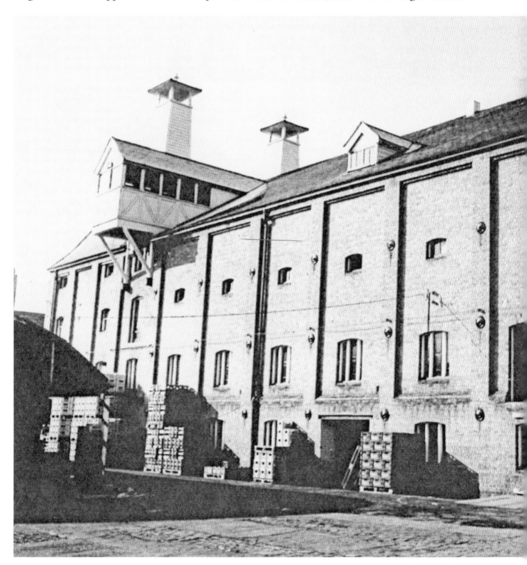

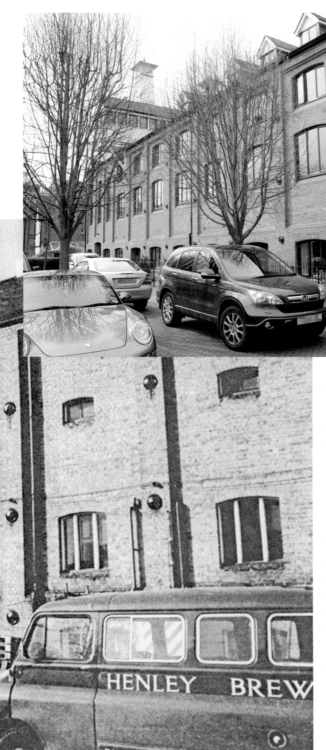

rivals Greys Brewery, and by the end of the century they supplied enough malt to brew over 14,000 barrels of beer a year. They are seen here in 1978 (left).
(Reproduced with kind permission of South Oxfordshire District Council)

MALTING CEASED IN 1972. These large open spaces were ideal for conversion into office accommodation, and were for many years occupied by a firm of computer software consultants. More recently, the building has been adapted for use as apartments. However, despite the changes to the windows, the character of the industrial building has been preserved, even to the extent of replacing the original ventilation cowls on the roof with replicas in fibreglass.

HENLEY STATION

HENLEY'S PROSPERITY SUFFERED when the Great Western Railway built its line through Reading and Twyford thus by-passing the town, but a link with the main line at Twyford was finally established, and on 1 June 1857 Henley railway station was opened. The new line enabled

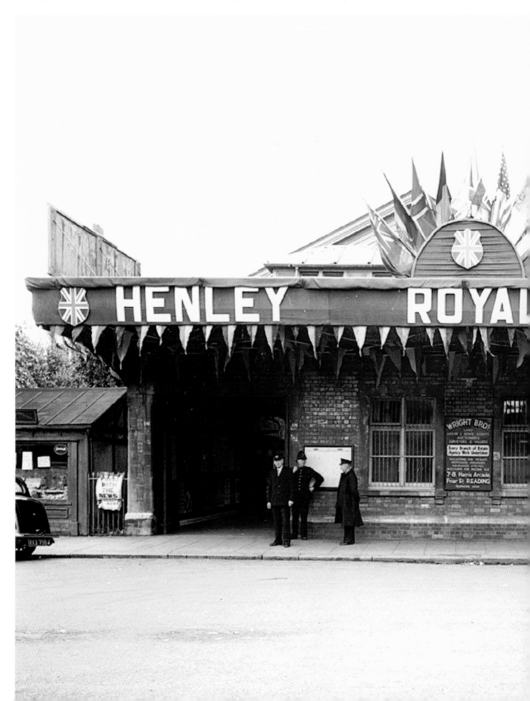

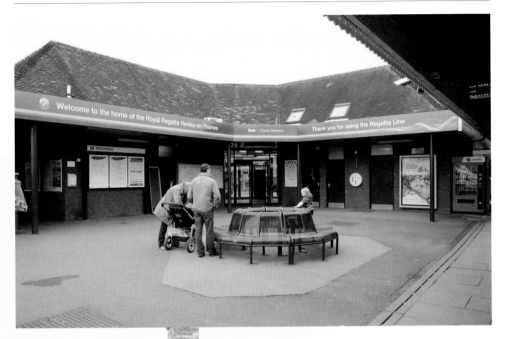

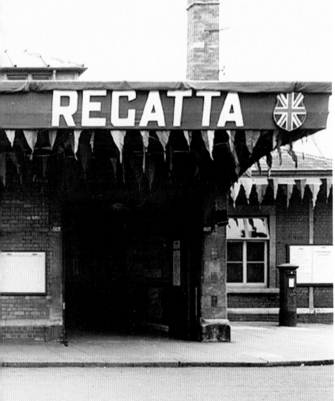

Henley to develop its regatta and tourist trade, but the impact on commercial river traffic and on coaching was dramatic. This photograph shows the old station in 1952, decorated with flags and bunting for the Henley Royal Regatta.

THE ORIGINAL STATION was demolished in 1975 and the present smaller station was opened in 1986. It was built as part of a joint development with Hallmark Cards, which entailed shortening the line and moving the station further from Station Road. Plans have been mooted to rebuild the station again on a new site further from the town centre, but they met with considerable local opposition. First Great Western are proud to badge the service as 'The Regatta Line'.

TRAINS AT HENLEY STATION

A STEAM LOCOMOTIVE about to depart Henley railway station on 17 September 1953 can be seen in the old photograph below. The small engine shed and water tank on the right of the photograph were used until 1958 and demolished in 1963, and behind it was a turntable, required because Henley was at the end of the line. The growing popularity of the Royal Regatta in the Edwardian era owed much to easy access to the town by railway, and extra trains from

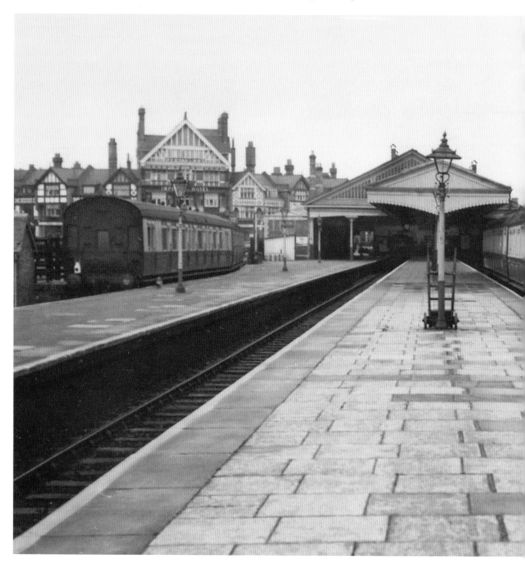

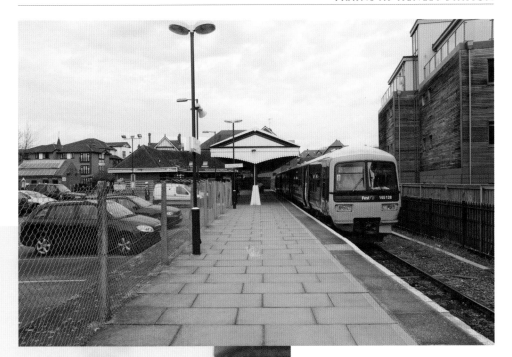

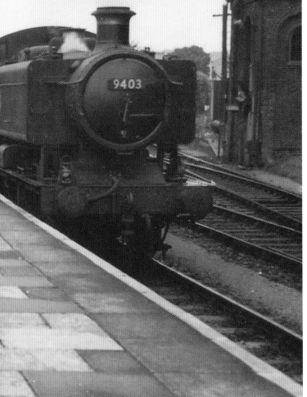

Paddington, Didcot and Oxford were laid on. In 1898, over 37,000 passengers were carried over the three days of the regatta.
(Reproduced with kind permission of Great Western Collection)

DIESEL TRAINS REPLACED steam in 1958 and the service today is operated by First Great Western. When the station was rebuilt in 1986, it was reduced in size from three platforms to a single platform, and cars now park where the other platforms once stood. However, the white-painted canopy dating from 1904 has survived, and behind it can be seen the high roof of the building which stands where the old station used to be. To the left can be seen the timbered gable of the Imperial Hotel, built in 1897 to accommodate fashionable visitors arriving by train.

THE ANGEL ON
THE BRIDGE

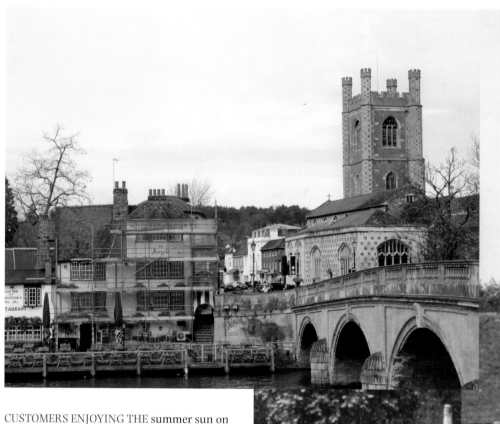

CUSTOMERS ENJOYING THE summer sun on
the river terrace of the Angel on the Bridge inn
can be seen in the old photograph *c.*1910 on
the right. The Angel on the Bridge has been
welcoming locals and visitors alike since at
least the eighteenth century, and part of its
cellar and north wall incorporate a flint and
stone arch of the earlier medieval bridge. Some
of the guests here are arriving by punt.

THE ANGEL ON the Bridge inn remains as
popular today and its river terrace is well
used on summer afternoons. It is currently
being repaired and repainted. The approach

to Henley from this direction is delightful, and St Mary's church stands as a landmark at the entrance to the town. Its origins go back to the early thirteenth century, and the decorative flint and stone chequer pattern of the sixteenth-century Lady Chapel visible here is particularly attractive. The tower is said to have been added by John Longland, bishop of Lincoln, between 1521 and 1547.

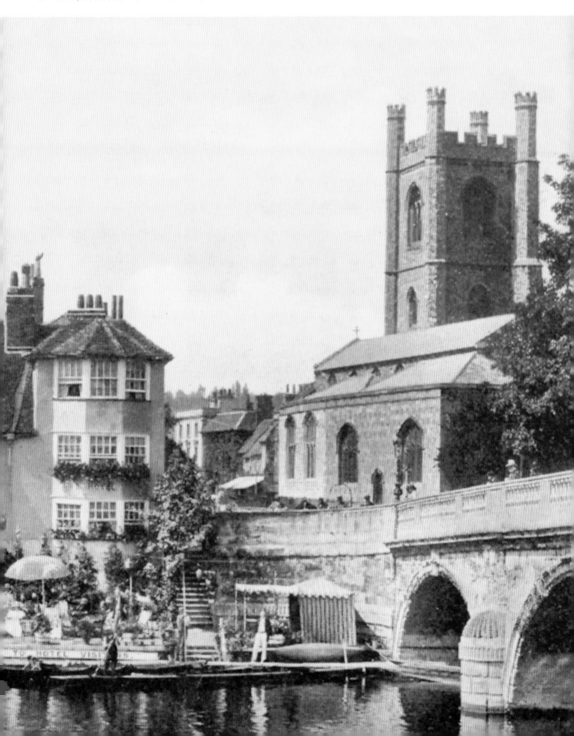

THE RED LION HOTEL

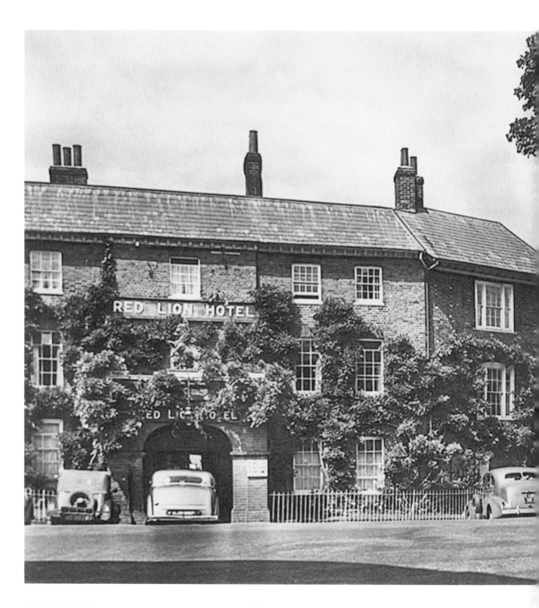

THE RED LION, seen here in 1942, is one of Henley's most prestigious hotels and it has a long history as a coaching inn. The present building dates from the eighteenth century when it was rebuilt to accommodate travellers arriving by coach on the new turnpike roads. The turnpikes revolutionised road travel, and it was now possible to reach London in just five hours from Henley! Travellers could choose between coaches such as the *Rocket*, which departed from the White Hart, the *Coach*, from the Red Lion and the *Regulator* from the Black Bull.

APART FROM THE cutting back of the wisteria from the entrance porch, this side of the Red Lion Hotel has changed little. Henley's coaching inns initially suffered from the opening of the railway; in 1830, when stagecoach travel was at its peak, some twenty-six coaches a day passed through Henley, but by the 1860s all these services had ceased, to be replaced by local shuttles to the station. However, most hotels recovered as the tourist trade grew, and today the Red Lion Hotel remains a popular stopping-off point for visitors on their way to Oxford, the Cotswolds and the west of England.

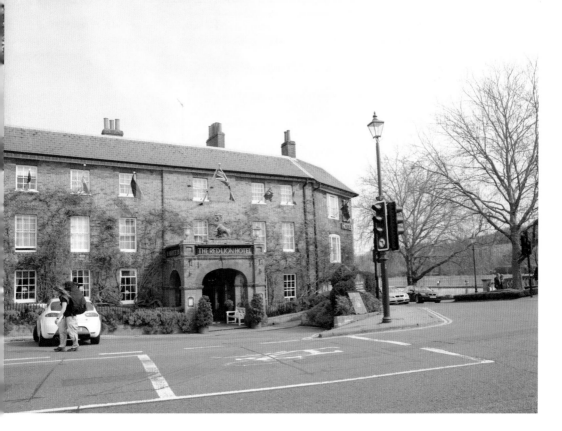

THE RED LION
HOTEL ENTRANCE

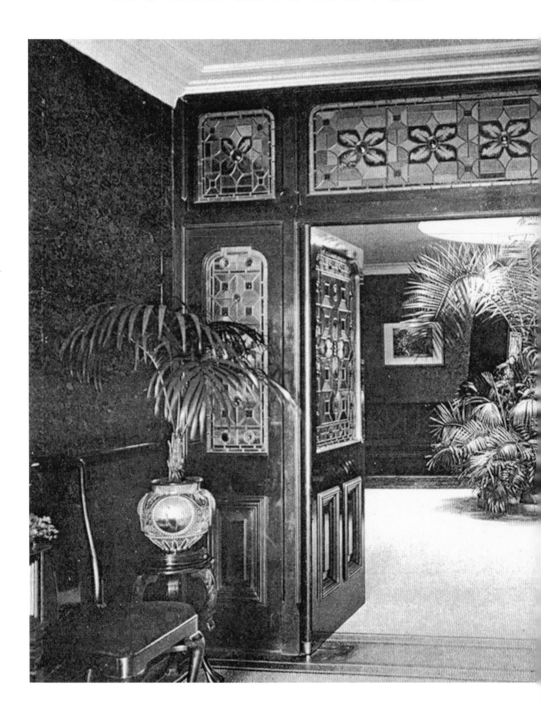

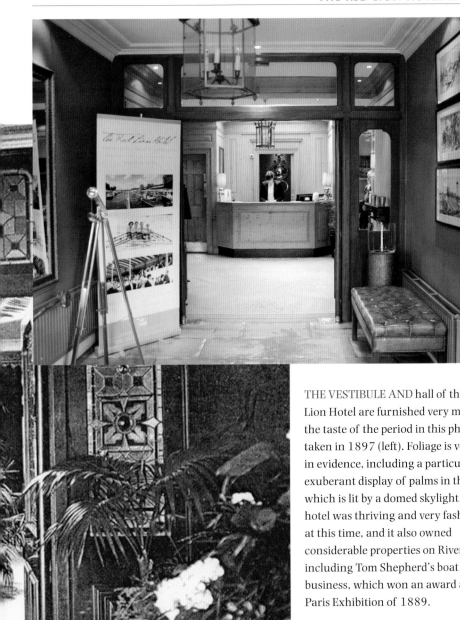

THE VESTIBULE AND hall of the Red Lion Hotel are furnished very much in the taste of the period in this photograph taken in 1897 (left). Foliage is very much in evidence, including a particularly exuberant display of palms in the hall, which is lit by a domed skylight. The hotel was thriving and very fashionable at this time, and it also owned considerable properties on Riverside, including Tom Shepherd's boat building business, which won an award at the Paris Exhibition of 1889.

RECENT REFURBISHMENTS HAVE stripped the woodwork, carpeted the floor, removed the stained glass – and dealt a fatal blow to the potted palms! The hotel has maintained its prestige and the week of the races remains one of its busiest times of year. The banner advertises Henley Royal Regatta hospitality.

THE OLD ROYAL HOTEL, THAMESIDE

THE OLD ROYAL Hotel on the corner of Station Road and Thameside. It was built by local entrepreneur Robert Outhwaite in 1869, and was conveniently situated near to the railway

station. Despite its central location with views over the river, this huge hotel was set in 14 acres of landscaped grounds, which included a croquet lawn and an Italian-style terrace walk.

THE HOTEL WAS not a commercial success and in 1900 it was demolished and a second Royal Hotel was built in its place. This time a Tudor style was chosen, with mock timber framing and steep gables, seen on the left-hand side of the modern photograph. However, it too closed in 1925 and the building was converted into apartments. The Royal was one of a number of luxury hotels built around this time to accommodate wealthy visitors arriving by train. Nearby, the Imperial Hotel was built in a flamboyant Jacobean style, and this has been restored to its former glory in recent years.

THE WHITE HART HOTEL

CHRISTMAS FARMERS' MARKET in the yard of the White Hart Hotel, Hart Street, in 1927 (below). The White Hart was the oldest pub in Henley and its origins go back to the 1420s.

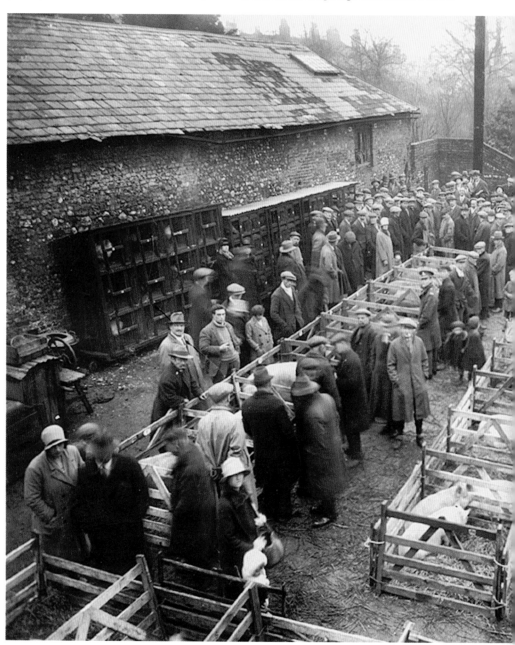

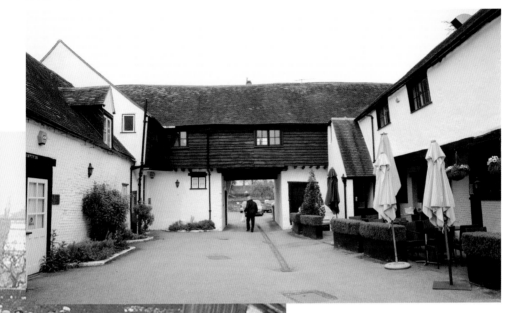

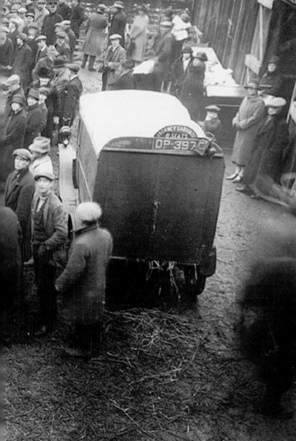

It was largely rebuilt in the sixteenth century to accommodate merchants drawn to the reviving grain trade and market, and in the 1830s it was the largest coaching inn in the town with stabling for seventy-three horses. After the collapse of the coaching trade, the hotel used its large stable yard for weekly farmers' markets.
(Reproduced with kind permission of Bushells Photographic)

THE WHITE HART closed in 1996, and in 1999 it was completely refurbished as a restaurant. The yard survives together with a large carriage arch from Hart Street and lodging ranges built in the 1530s, which originally contained twenty-two guest rooms (built above stables) and service rooms. An external timber gallery would have run around the whole yard to give access to the rooms, and the west range contained a hall for eating, open from floor to roof, with a brick fireplace in the south gable.

THE BASKETMAKER'S ARMS

THE BASKETMAKER'S ARMS at the top of Gravel Hill (right). In the middle of the nineteenth century there were five breweries operating in the town, and most of the beer was consumed locally. Even by the 1950s, when this photograph was taken, there were thirty-seven public houses open for business in Henley. However, many of them were so small that they were insufficient to provide a living and the landlord had to find other employment during the day. *(Reproduced with kind permission of Brakspear Pub Company)*

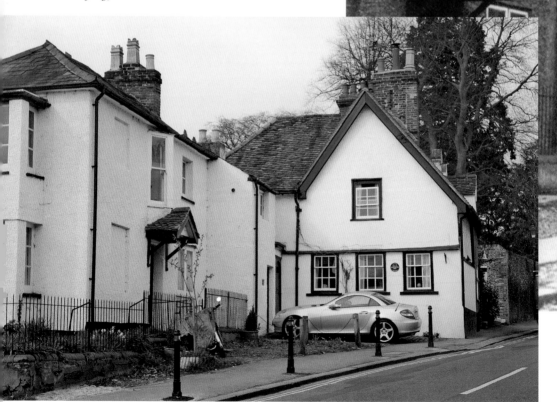

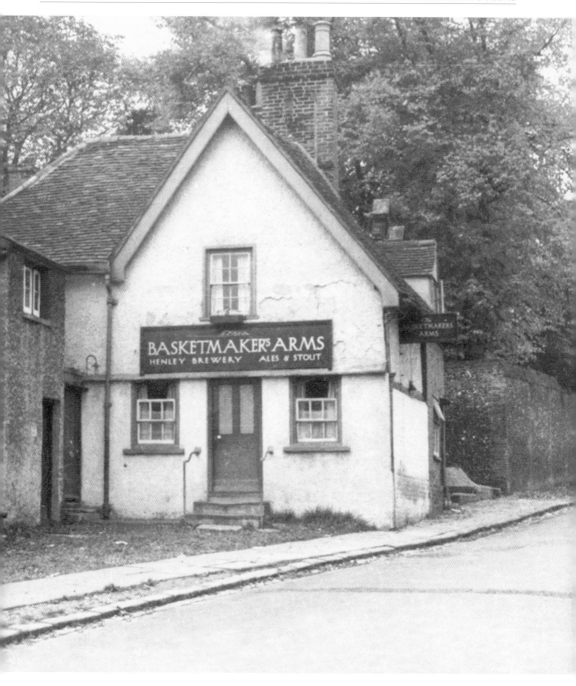

THE BASKETMAKER'S ARMS is first recorded as a beerhouse and lodging house in 1841. In more recent times, pubs have been closing rather than opening, and the trend has accelerated in the twenty-first century, especially outside the town centre. This pub closed in 1972 and is now a private house called the Old Basketmaker's Arms.

TAKING TO THE RIVER

TAKING TO THE river became a popular pastime for the leisured classes in the latter decades of the nineteenth century, and Henley's beautiful surroundings made it a magnet for visitors by boat. Steam launches, often finely appointed in brass and mahogany, made a particular impression, and this one, the *Conway*, is taking a group of guests on an outing from Park Place in 1898. They are all fashionably dressed in clean shirts and straw boaters, and are

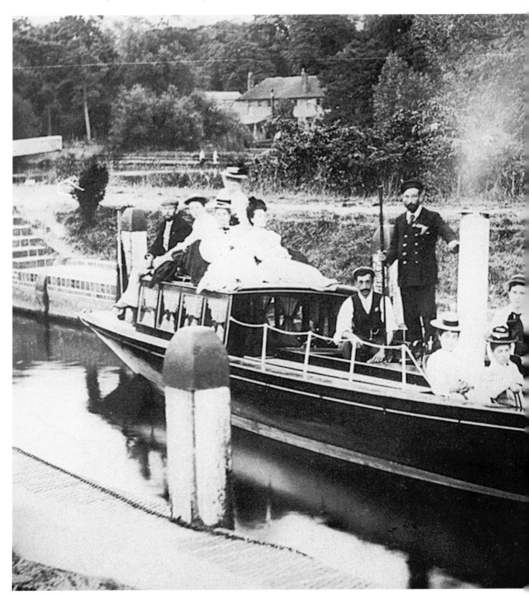

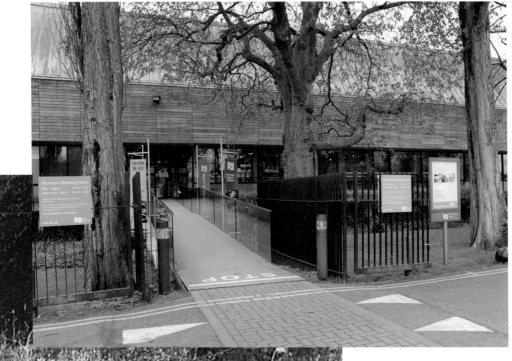

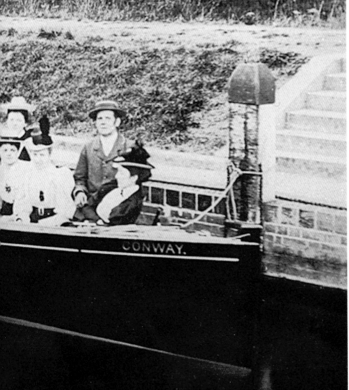

clearly leaving the dirty work to the captain.

SADLY, THE STEAM launches are no more, but examples of every type of river craft can be seen in the River and Rowing Museum, opened in 1998 in Mill Meadows. The history of Henley's close relationship with its river is well portrayed, from medieval times to the present day, including the story of the regatta, and it draws locals and tourists alike to its displays and popular café. The galleries are clad externally in timber and look almost like upturned boats from the outside, but inside they are full of natural light.

MESSING ABOUT IN BOATS

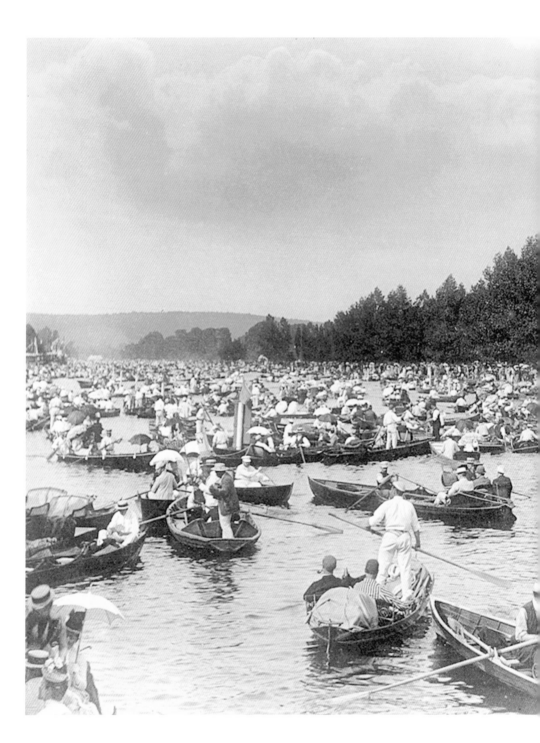

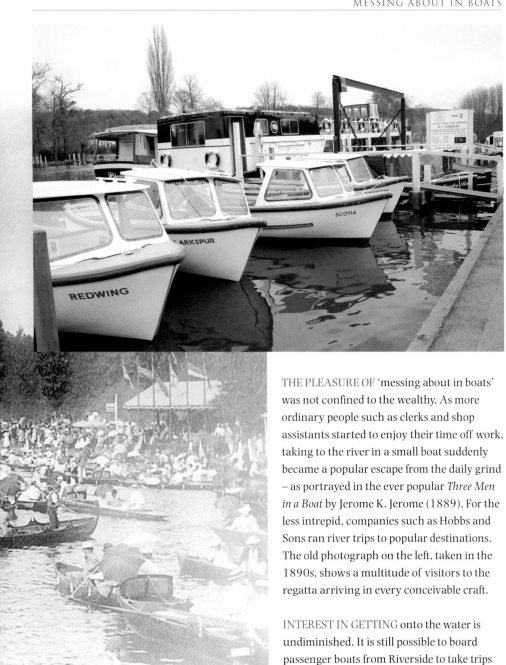

THE PLEASURE OF 'messing about in boats' was not confined to the wealthy. As more ordinary people such as clerks and shop assistants started to enjoy their time off work, taking to the river in a small boat suddenly became a popular escape from the daily grind – as portrayed in the ever popular *Three Men in a Boat* by Jerome K. Jerome (1889). For the less intrepid, companies such as Hobbs and Sons ran river trips to popular destinations. The old photograph on the left, taken in the 1890s, shows a multitude of visitors to the regatta arriving in every conceivable craft.

INTEREST IN GETTING onto the water is undiminished. It is still possible to board passenger boats from Riverside to take trips up the river to Marsh Lock, Temple Island and Hambleden Lock, and to visit the regatta course. Other people prefer to hire a rowing boat or indeed to arrive on their own motor launches, many of which are equipped for the open seas.

ARRIVING AT THE REGATTA

HENLEY IS KNOWN throughout the world as the home of the Royal Regatta. In 1829 the
University Boat Race was held on this stretch of the river and in 1839 the town decided to stage its

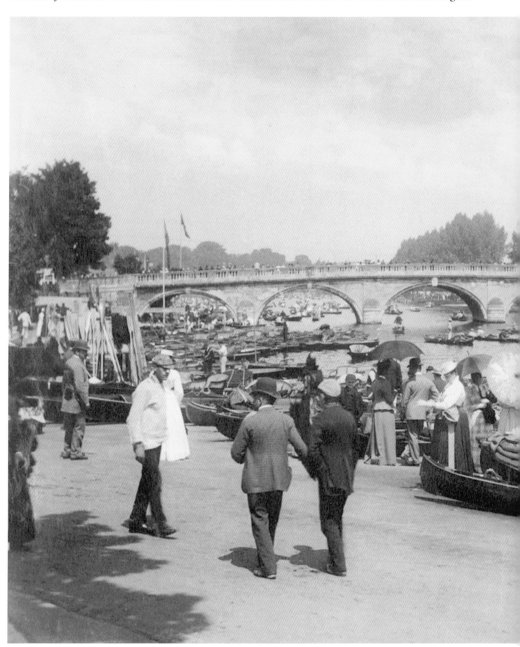

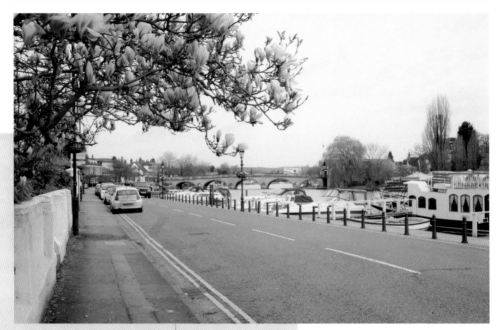

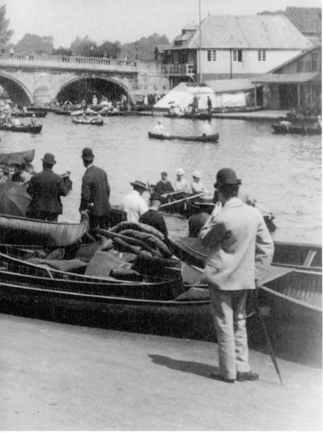

own event in the same place. The regattas really took off with the patronage of Prince Albert in 1851 and after the opening of the railway in 1857, and by 1895, more than 34,000 people were arriving over the three days of the races. This photograph of about 1890 shows spectators arriving on Thameside from the railway station.

MODERN REGATTAS CAN attract over 50,000 people to the town and 9 mile traffic queues are not unknown. However, many continue to arrive by train and walk this way up Thameside as they always have. This particularly beautiful part of Henley links the town with Mill Meadows and Marsh Lock. The Angel can be seen on the left by the bridge, and the Henley Royal Regatta Headquarters sits behind the willow tree on the other side of the river.

THE ROYAL REGATTA

THE REGATTA IS held during the twenty-seventh week of the year, usually the first week of
July, and during this time the banks of the river used to be lined with luxuriously furnished

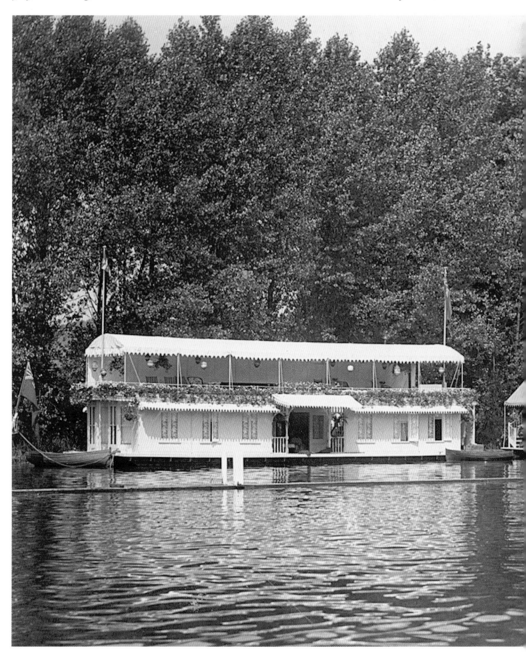

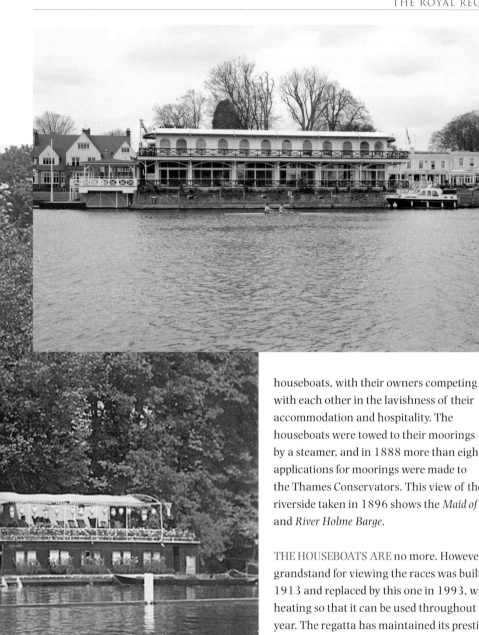

houseboats, with their owners competing with each other in the lavishness of their accommodation and hospitality. The houseboats were towed to their moorings by a steamer, and in 1888 more than eighty applications for moorings were made to the Thames Conservators. This view of the riverside taken in 1896 shows the *Maid of Kent* and *River Holme Barge*.

THE HOUSEBOATS ARE no more. However, a grandstand for viewing the races was built in 1913 and replaced by this one in 1993, with heating so that it can be used throughout the year. The regatta has maintained its prestige in the social calendar and has also built its reputation as a world-class sporting event, staging up to 100 races each day. It has continued to thrive, helped by the hosting of corporate hospitality events. By 2005, the total cost of mounting the regatta had risen to £1.76 million, with income exceeding this sum by £485,000.

Other titles published by The History Press

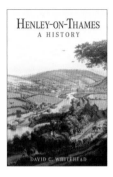

Henley-on-Thames: A History
DAVID C. WHITEHEAD

Henley-on-Thames. For many people the name conjures up images of Henley Royal Regatta, of relaxed afternoons by the Thames, of large houses with spacious lawns. For its residents, and residents of the surrounding villages, the dominant images are more likely to be of traffic jams, narrow pavements, supermarkets and late-night brawls. Both views are, of course, far from complete and tend to hide the reality of a working and commuter town with a character that reflects the impact of several centuries of history.

978 1 8607 7452 2

The Changing Thames
BRIAN EADE

A collection of over 200 photographs comparing scenes from days gone by with contemporary views, all the way from the river's source in Gloucestershire to Teddington Lock. Images of houses and pubs, lock-keeper's cottages and industrial buildings are juxtaposed with photographs of river traffic, leisure and working boats, as well as wharfs, weirs and locks. Brian Eade's affectionate portrait of the Thames illustrates the changing face of Britain's favourite river and will delight river people and visitors alike.

978 0 7509 4779 4

Oxfordshire Murders
NICOLA SLY

Oxfordshire Murders brings together twenty-five murderous tales, some which were little known outside the county and others which made national headlines, including the the deaths of two gamekeepers, brutally murdered in 1824 and 1835; Henrietta Walker, killed by her husband in 1887; and Anne Kempson, murdered by a door-to-door salesman in 1931. Nicola Sly's enthralling text will appeal to anyone interested in the shady side of Oxfordshire's history

978 0 7524 5359 0

Working Oxfordshire: From Airmen to Wheelwrights
MARILYN YURDAN

Featured in this book are carvers and barrel makers, university employees and leather-workers, hop-pickers and bee-keepers, brewers and marmalade makers, railwaymen and bus drivers, thatchers and blacksmiths, and, of course, shops galore. With 200 superb photographs, this book will appeal to everyone with an interest in the history of the county, and also awaken memories of a bygone time for those who worked, shopped or simply remember these Oxfordshire firms, trades and businesses.

978 0 7524 5585 3

Visit our website and discover thousands of other History Press books.

www.thehistorypress.co.uk